lighting | for still life

Steve Bavister

RotoVision

lighting | for still life
Steve Bavister

A RotoVision Book.
Published and distributed by
RotoVision SA, Rue du Bugnon 7
CH-1299 Crans-Près-Céligny
Switzerland

RotoVision SA, Sales, Production & Editorial Office
Sheridan House, 112–116A Western Road
Hove, East Sussex BN3 1DD, UK

Tel: +44 (0) 1273 72 72 68
Fax: +44 (0) 1273 72 72 69
E-mail: sales@rotovison.com
Website: www.rotovision.com

ISBN 2–88046–513–3

10 9 8 7 6 5 4 3 2 1

Book design by Red Design

Production and separations in Singapore by ProVision
Pte. Ltd.

Tel: +65 334 7720
Fax: +65 334 7721

contents

lighting...

No matter how experienced we are as photographers there's always something new to learn – and this is never more true than when it comes to lighting. Whether you developed your skills in this area by watching master photographers at work, or from reading books and magazines, or simply through trial and error, you will almost certainly have built up a small repertoire of techniques that you come back to time and again. But endlessly recycling your set-ups can get boring and repetitive. Not only for you, but also for your clients. What's more, styles of lighting change over time, and without realising it you can suddenly find your work looking dated – and neither successful nor saleable. So given that lighting is arguably the single most important element in any photograph, it's essential to keep up with contemporary trends.

RotoVision's LIGHTING... series of books seeks to answer these needs. Each title features a selection of current, high-style images from leading exponents in that particular field who have been persuaded to share their lighting secrets with you. In most cases we have talked to the photographer at length to find out exactly where everything was positioned and why one kind of accessory was used over another. At the same time we also picked up a lot of useful suggestions and general information which have also been included. Some of the images rely purely upon daylight; in others ambient illumination is combined with flash or tungsten lighting; and some feature advanced multi-head arrangements. As a result, the LIGHTING... series provides a wonderfully rich smorgasbord of information which would be impossible for you

to find collected together in any other way. Each self-contained two- or four- page section focuses on an individual image or looks at the work of a particular photographer in more depth. Three-dimensional lighting diagrams show you the lighting set-up at a glance – allowing you to replicate it for your own use – while the commentary explains in detail what was involved. Whenever possible, also included are additional images that were either taken at the same time or using the same technique, or illustrate an alternative treatment.

Who will find this book useful? Anyone looking to improve their photography, whether it be for pleasure or profit. Professionals, or those looking to make the move from amateur to professional, will find it an invaluable source of inspiration to spice up their own image-making. Each of the photographs here is designed to help fire the engine of your imagination and encourage your creativity to flow in a different and more interesting direction. Alternatively, you may be looking to solve a particular picture-taking problem. You've got a job to do and you're unsure of the best approach. Or you've run low on ideas and want to try out some new techniques. If so, simply flip through the pages until you come across an image that has the kind of feel or look you're after and then find out how it was created.

Art directors, too, will find each title an invaluable primer on contemporary styles as well as a source for new photographic talent. Ultimately, though, LIGHTING... will appeal to anyone who enjoys looking at great pictures for their own sake, with no other motive in mind.

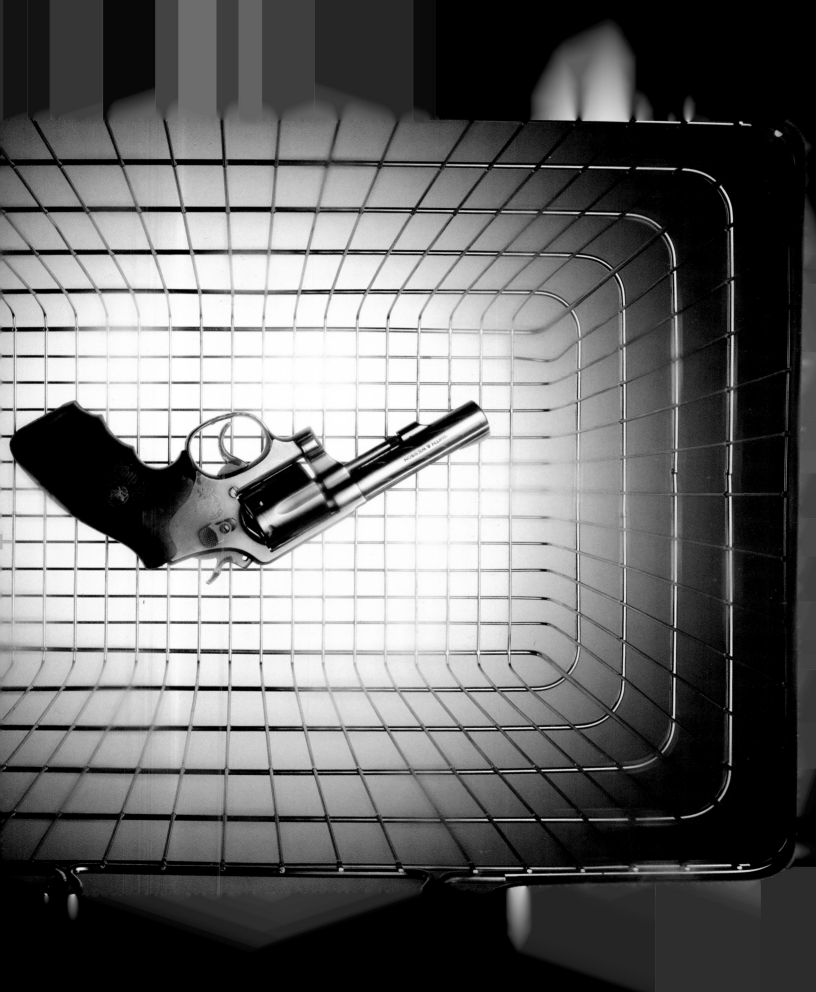

... still life

It goes without saying that skilled and suitable lighting is crucial in all areas of photography, but nowhere is this more true than when it comes to still life. Working with subjects that are often relatively small means that pinpoint lighting precision is required if the full potential of the shot is to be realised.

For this reason, and because of the exacting demands of clients, still-life work is almost exclusively carried out in the studio. Only with certain subjects – such as cars – is it possible for the photographer to use existing light.

defining 'still life'

As ever, the great advantage of working in the studio is the complete control it offers. Shots can be built up slowly, methodically and surely, to create the mood and convey the message intended – or at least as slowly, methodically and surely as the budget allows! Nothing is left to chance. Everything can be perfect.

Often, of course, the photographer will be working to a brief provided by a creative director or by a client. Though sometimes the commission may simply consist of an instruction to 'make this look interesting', which can be something of a challenge when the item in question is just another anonymous-looking piece of industrial equipment.

It is difficult to say exactly what is meant by 'still-life' photography, though for most professionals, table top-work featuring products for advertising, catalogue and editorial use would almost certainly fall into that category. In addition, many professionals working in areas such as fashion and portraiture seem drawn to still-life photography when they feel the need to produce

some personal work. This may simply be for their own pleasure, as an avenue for exploring ideas, or as a vehicle for self-promotion.

Amateur photographers, on the other hand, tend to shy away from still life – favouring instead subjects such as landscape, people and buildings. This is a great shame, as the skills developed by spending time on still-life work are valuable in all areas of picture-taking.

composition

What skills are required? Well, patience for one thing. Although shots are occasionally 'snapped' in just a few seconds, more commonly the composition is painstakingly put together over a period of hours and maybe even days. Sometimes plain paper or textured canvas backdrops are used, but it's not unusual for a 'set' to be built in the studio that creates the context for the shot. Depending upon the size of the job, it may be the responsibility of the photographer to gather together any props that are needed or, if the brief is loose, come up with suggestions about what may be required. It will certainly fall to the photographer to create an effective composition. Time should be allowed for this, you need to play around with the various elements until they 'come together' effectively.

You also need to be meticulously clean and a stickler for details. With still-life photography you're often filling the frame with relatively small subjects, so any flaws will be immediately evident. It's not unknown for food photographers to sift through 20 tins of baked beans for five individual beans of just the right shape. You must also clean everything thoroughly. It's a nuisance, not to mention an embarrassment, having to get finger or dust marks retouched out at a later stage.

lighting considerations

Having composed the shot effectively, the important matter of lighting has to be considered if it has not been already planned while the shot was being composed. Often in still-life work the aim is to mimic daylight, so relatively few lights are used; sometimes just one head, perhaps fitted with a softbox, and suspended on a boom arm over the set, or to one side for greater modelling. Adding a second head gives more options, allowing the lighting ratio to be controlled more easily. Further heads can be used to light the backdrop or to add highlights, but care must be taken not to 'overlight' and make the shot look unnatural. Small mirrors and black card are often a better way of making subtle but important adjustments. Coloured gels, which are often used to breathe life into what might otherwise be a dull shot, can be valuable, but once again need using with discretion.

What is important, as in other areas of photography, is that the lighting be adapted to suit the subject, rather than having a standard set-up that's used for everything. The many different approaches explained in this book will provide inspiration should you find yourself getting in a rut.

equipment

The kinds of clients, markets and uses for which still life is commissioned mean that the finished image must be of an extremely high quality. This means that although 35mm may sometimes be used, perhaps where a grainy image is required, medium-format and sheet-film cameras are more the norm. The format of these cameras, used together with slow film, preferably transparency on account of its wider contrast range, mean that images can be blown up considerably without significant loss of sharpness or detail.

While medium format cameras, from 6 x 4.5cm to 6 x 9cm, offer excellent economy, many leading professionals prefer large format cameras. Not only do you get a full range of movements on 5 x 4 and 8 x 10 inch cameras, which are useful in controlling perspective and either limiting or extending depth of field, you also benefit from a much larger Polaroid with which to judge how things are going.

However, at the end of the day, still life is not about equipment or film. It's about the photographer's eye, and the ability to create an eye-catching image from simple elements using mainly composition and lighting. Whatever changes may take place in the way photographs are taken, such skills will always be in demand — as the many stunning photographs in this book bear testimony.

understanding light

The raw material of the photography profession.

Every art or business has its raw material. To create a pot requires clay. For a statue you must have stone. And to produce a painting you need some kind of paint.

But what about photography – what's our raw material? The answer of course is light. You can have all the cameras, lenses, accessories and film in the world, but without light you won't get very far.

In the same way that other artists have to fashion their raw material, so photographers have to learn to work with light if they're to be successful. Indeed, as many of you will know, the very word 'photography' derives from Greek and means 'painting with light' – still an excellent way of describing what it is we do.

The most astonishing thing about light is its sheer diversity – sometimes harsh, sometimes soft; sometimes neutral, sometimes orange, sometimes blue; sometimes plentiful and sometimes in short supply.

Given that light is the single most important element in any photograph, it's astonishing how few photographers pay any real attention to it.

Many – even professionals! – can be so eager to press the shutter release and get the shot in the bag that they don't pay light the attention it deserves. However, for successful photography, an understanding of light and the ability to use it creatively, are absolutely essential.

The best way of developing and deepening that understanding is to pay close attention to the many moods of daylight. You might find yourself noticing how beautiful the light is on the shady side of a building, or coming in through a small window, or dappled by the foliage of a tree. Use that awareness and knowledge when creating your own lighting set-ups.

quality versus quantity

Taking pictures is easier when there's lots of light. You're free to choose whatever combination of shutter speed and aperture you like without having to worry about camera-shake or subject movement – and you can always reduce it with a neutral density filter if there's too much. But don't confuse quantity with quality.

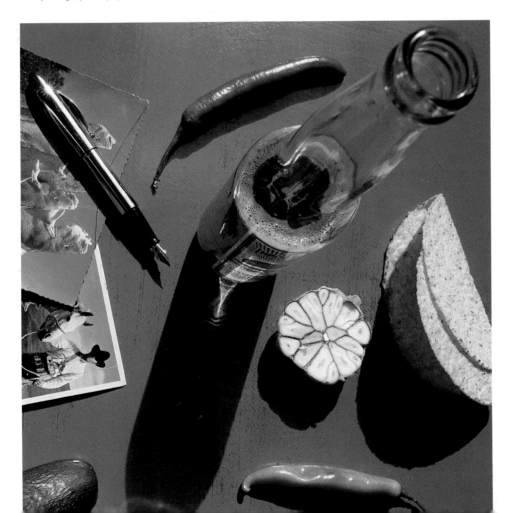

The blinding light you find outdoors at noon on a sunny day or bursting out of a bare studio head may be intense, but it's far from ideal for most kinds of photography.

More evocative results are generally achieved when the light is modified in some way – with overall levels of light being often much lower. With daylight this modification might be by means of time of day, early morning and late evening being more atmospheric, or by weather conditions, with clouds or even rain or fog producing very different effects. Some of the most dramatic lighting occurs when opposing forces come together – such as a shaft of sunlight breaking through heavy cloud after a storm.

In the studio, as well as the number of lights used – more isn't necessarily better – and their position, it's the accessories you fit which will determine the overall quality of the light (see pp16–18).

soft and hard

For some situations and subjects you will want light that is hard and contrasty, with strong, distinct shadows and crisp, sharp highlights. When it's sunny outdoors the shadows are darker and shorter around noon, and softer and longer when it's earlier, or later in the day. Contrasty lighting can result in strong, vivid images with rich, saturated tones if colour film has been used.

However, the long tonal range you get in such

conditions can be difficult to capture on film, especially when using transparency materials – you may have to allow either the highlights to burn out slightly or the shadows to block up. Care must be taken when doing so that no important detail is lost or that the image doesn't then look either too washed-out or too heavy. If so, some reduction in contrast can often be achieved by using reflectors.

This kind of contrasty treatment is not always appropriate or suitable and for many subjects and situations a light with a more limited tonal range that gives softer results may work better. Where you want to show the maximum amount of detail, or create a mood of lightness and airiness with the minimum of shadows, the soft lighting of an overcast day or a large softbox is unbeatable.

Here the principal risk is that the picture will be too flat to hold the viewer's interest – though imaginative design and composition should avoid that problem.

In the studio, you have full control over the contrast, which you will choose on the basis of what is most appropriate.

lighting direction

In every picture you take you are using light to reveal something about the subject – its texture, form, shape, weight, colour or even translucency. That's where to a large degree the direction of the lighting comes in. Looking at what you are going to photograph, and thinking about what you want to convey about it, will give you some idea about the best lighting direction to employ.

colour temperature

We generally think of light as being neutral or white, but in fact it can vary considerably in colour – you need only think about the orange of a sunrise or the blue in the sky just before night sets in. The colour of light is measured in Kelvins (K), and the range of possible light colours makes up the Kelvin scale. Standard daylight-balanced film is designed for use in noon sunlight, which typically has a temperature of 5500K – the same as electronic flash. However, if you work with daylight film in light of a lower colour temperature you'll get a warm, orange colour, while if you work with it in light of a higher temperature, you'll get a cool, blue tonality. Such casts are generally regarded as wrong, but if used intentionally they can give a shot more character than the blandness of a clean white light – as many excellent shots in this book testify most eloquently.

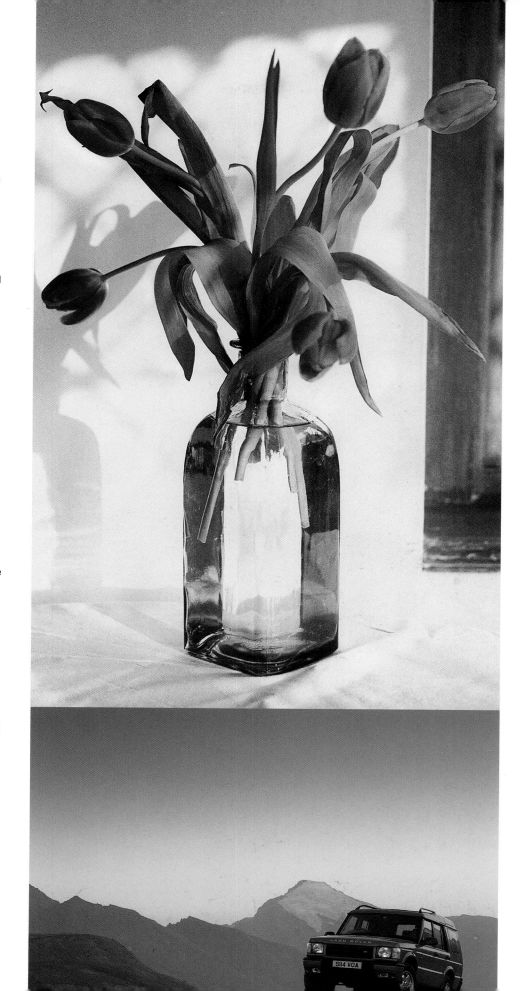

measuring light

All you ever wanted to know about using a meter but were afraid to ask.

in-camera meters

Over recent years the accuracy of in-camera meters has advanced enormously, and many autofocus models now boast computerised multi-pattern systems whose processing power would have filled the average lounge in the 1960s. By taking separate readings from several parts of the subject and analysing them against data drawn from hundreds of different photographic situations, they deliver a far higher percentage of successful pictures than ever before.

However, the principal problem with any kind of built-in meter remains the fact that it measures the light reflected back from the subject – so no matter how sophisticated it may be, it's prone to problems in tricky lighting situations, such as severe backlighting or strong sidelighting.

An additional complication is that integral meters are stupid – in the sense that they don't know what you're trying to do creatively. So while you might prefer to give a little more exposure to make sure the shadows have plenty of detail when working with black & white negative film, or to reduce exposure by a fraction to boost saturation when shooting colour slides, your camera's meter will come up with a 'correct' reading that produces bland results.

Of course, not all in-camera meters are that sophisticated. Many photographers still use old and serviceable models with simple centre-weighted systems that are easily misled in all sorts of situations.

For all these reasons, any self-respecting professional photographer or serious amateur should invest in a separate, hand-held lightmeter, which will give them full control over the exposure process – and 100 percent accuracy.

incident light meters

Hand-held meters provide you with the opportunity to do something your integral meter never could – which is take an 'incident' reading of the light falling onto the subject. With a white 'invercone' dome fitted over the sensor, all the light illuminating the scene is integrated, avoiding any difficulties caused by bright or dark areas in the picture.

Using an incident meter couldn't be easier. You simply point it toward the camera and press a button to take a reading. Most modern types are now digital, and you just read the aperture or shutter speed off an LCD panel, sliding a switch to scroll through the various combinations available. With older dial types you read the setting from a scale.

When using filters, you can either take the reading first and then adjust the exposure by the filter factor if you know it, or hold the filter over the sensor when making a measurement.

To those who've grown to rely on automated in-camera systems, this may sound a long-winded way of going about things. But in fact once you've used a separate meter a few times you'll find it doesn't take much longer. What does it matter if it takes a few seconds more to get a good result?

Most of the time the exposure calculated by an incident meter can be relied upon, but there are a couple of situations where you might need to make some slight adjustment:

1. When the main subject is either much darker or lighter than normal. Here, to get good reproduction, you may need to increase exposure by 1/2 to 1 stop with dark subjects and decrease exposure by 1/2 to 1 stop with light subjects.

2. When contrast levels are extremely high and beyond the film's ability to accommodate them. Here, it's often necessary to give 1/2 or even 1 stop extra exposure to prevent the shadows blocking up.

spot meters (a)

Those seeking unparalleled control over exposure should consider buying a spot meter, which allows you to take a reading from just one percent of the picture area. Many photographers involved in all kinds of picture-taking swear by theirs and would be completely lost without it.

Spot meters are different from incident meters in that they have a viewfinder which you look through when measuring exposure. At the centre is a small circle, which indicates the area from which the reading is made. Of course, considerable care must be taken when choosing this area.

If you plan to measure the exposure from just one area, you need to make sure it's equivalent in tone to the 18 percent middle grey the meter expects. Grass is usually about right, as is dark stonework on a building. To be sure, it's a good idea to carry around a Kodak Grey Card, designed specifically to give average reflectance.

Another alternative is to take a 'duplex' reading – measuring the lightest and darkest parts of the scene and then taking an average. Most spot meters offer a facility which does this automatically.

In some pictures it's the correct rendering of the light or dark tones that's important, and some spot meters feature clever Highlight and Shadow buttons that ensure they come out correctly.

(a)

(b)

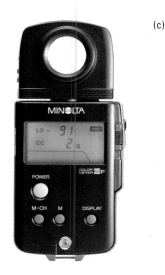
(c)

reciprocity law failure

The ISO ratings that manufacturers give their film assume that they have the same sensitivity whatever the aperture or shutter speed combination – that the exposure will be the same at 1/60sec and f/2 as at 1/4sec and f/8 as at 4 seconds and f/32. This is called the Reciprocity Law – but it's not always true.

If the shutter is longer than about 1 second, or shorter than around 1/4000sec, the law can break down and cause underexposure. The way to correct this is obviously to give an increase to compensate, but the problem is that films vary enormously in terms of their reciprocity characteristics, so you may need to experiment with your favourite emulsion if you do a lot of long exposure work.

As a starting point, increase exposure by 0.5 stops if the shutter speed is 1/4sec, by 1 stop if it's 16 seconds, and by 2–3 stops if it's 1 minute – although many manufacturers warn against using such long speeds because of the danger of significant colour shifts.

exposure latitude

If film manufacturers have anything to say on the matter, one day soon you won't need to make exposure adjustments – no matter how much the camera's meter is misled. By steadily increasing the exposure latitude of films – that is the degree to which they can be under- or overexposed and still give good results – they plan to make it all but impossible to get a bad result.

It is claimed that modern print films have a latitude of 5 stops – 3 stops over and 2 stops under. Certainly on the overexposure front the claims are justified. Pictures given 3 stops more than required are generally indistinguishable from those that received the right amount of light.

Underexposure can be more of a problem. Give 1 stop less than is required and the prints are generally still OK, but underexpose by 2 stops and you often get significantly inferior results.

With slides, though, it's a different story. The latitude is a lot less – rarely more than 1 stop – and with some films, such as Fujichrome Velvia, as little as 1/2 stop with critical subjects. This means careful exposure compensation is crucial when shooting trannies.

flash meters (b)

Many of the more expensive hand-held meters, both incident and spot, have a facility for measuring electronic flash as well. For those who don't feel the need for an ambient meter, separate, reasonably-priced, flash-only meters are available.

The benefit of having a meter that can measure flash is obvious. In the studio it allows you to make changes to the position and power of lights and then quickly check the exposure required. When using a portable electronic gun, you can calculate the amount of flash required to give a balanced fill-in effect.

Incident flash meters are used in exactly the same way as when taking an ambient reading. The meter is placed in front of the subject, facing the camera, and the flash fired. This can usually be done from the meter itself, by connecting it to the synchronisation cable and pressing a button.

The flash facility on spot meters is particularly helpful for making sure that the important part of the picture is correctly exposed. When shooting a portrait, for instance, a close-up reading can be taken of the subject's face.

Another widely available feature allows you to compare flash and ambient readings – this is ideal for balancing flash with ambient light or mixing flash with tungsten.

Some of the more advanced flash meters can also total multiple flashes – this can assist if you need to fire a head several times to get a small aperture for maximum depth of field.

colour temperature meters (c)

Colour temperature meters are specialist pieces of equipment that are not essential, but most photographers would benefit from one. These measure not the amount of light, but its colour.

The standard measure for the colour of light is Kelvins (K). Daylight film is balanced for use at 5500K, although the actual colour of daylight varies considerably. On an overcast day it can be higher, 6000–7000K, producing a blue cast, or in late afternoon 4000K, giving an orange tinge.

A simple press of a button on a colour meter can confirm the exact colour temperature and tell you what light balancing filter(s) would be required to correct it.

It also works with tungsten lighting, and the most difficult type of light to work with, fluorescent, indicating the necessary colour correction filter(s) needed to produce a neutral print.

You may not need a colour meter if you work mainly with colour negative film, but, if you use transparency film where colour accuracy is essential, it can be a worthwhile investment.

using light

If light is your raw material, how do you fashion it to produce the results you want?

working with daylight

One option for certain kinds of work is to run your studio on daylight – and some professionals do just that. Consider the advantages: the light you get is completely natural, unlike flash you can see exactly what you're getting, and it costs nothing to buy or run.

When working outdoors, light can be controlled by means of large white and black boards which can be built around the subject to produce the effect required.

Indoors, you might want to choose a room with north-facing windows. Because no sun ever enters, the light remains constant throughout the day. It may be a little cool for colour work – giving your shots a bluish cast. If so, simply fit a pale orange colour correction filter over the lens to warm things up – an 81A or 81B should do fine.

Rooms facing in other directions will see changes of light colour, intensity and contrast throughout the day. When the sun shines in you'll get plenty of warm-toned light that will cast distinct shadows. With no sun, light levels will be lower, shadows softer, and colour temperature more neutral.

The size of the windows in the room also determines how harsh or diffuse the light will be. Having a room with at least one big window, such as a patio door, will make available a soft and even light. The effective size of the window can easily be reduced by means of curtains or black card, for a sharper, more focused light. In the same vein, light from small windows can be softened with net curtains or tracing paper. The ideal room would also feature a skylight, adding a soft downwards light.

Whatever subject you're shooting, you'll need a number of reflectors to help you make the most of your daylight studio – allowing you to bounce the light around and fill in shadow areas to control contrast.

using studio lights

Daylight studios have many merits as the pictures in this book taken using ambient light demonstrate. There are, however, obvious disadvantages: you can't use them when it's dark, you can't turn the power up when you need more light, and you don't have anywhere near the same degree of control you get when using studio heads.

Being able to place lights exactly where you want them, reduce or increase their output at will, and modify the quality of the illumination according to your needs means the only limitation is your imagination. Any visualised lighting set-up is possible (although you might need to hire a few extra lights when you start to get more ambitious).

how many lights do you need?

Some photographers seem to operate on the basis of 'the more lights the better', using every light at their disposal for every shot. In fact there's a lot to be said for simplicity – there's only one sun, after all – and some of the best photographs are taken using just one perfectly positioned head. By using different modifying accessories you can alter the quality of its output according to your photographic needs. Before going onto more advanced set-ups, it's a good idea to learn to make the most of just a single light source – trying out backlit and sidelit techniques as well as the more usual frontal and 45 degree approaches. If you want to soften the light further and give the effect of having a second light of lower power, a simple white reflector is all you need.

Of course, having a second head does give you many more options – as well as using it for fill-in you can place it alongside the main light, put it over the top of the subject, or wherever works well.

Having two lights means you can also control the ratio between them, reducing or increasing their relative power to control the contrast in the picture. For many subjects a lighting ratio of 1:4 – i.e. one light having 1/4 of the power of the other – is ideal, but there are no hard-and-fast rules and experimentation often yields exciting and original results.

In practice, many photographers will need to have at least three or four heads in their armoury – and unless advanced set-ups or enormous fire power are required, that should be sufficient for most situations.

However, it is worth reiterating that it is all too easy to overlight a subject, with unnatural and distracting shadows going in every direction. Before you introduce another light try asking yourself what exactly it adds to the image – and if it adds nothing, don't use it.

flash or tungsten?

The main choice when buying studio heads is tungsten or flash – and there are advantages and disadvantages to both.

Tungsten units tend to be cheaper and have the advantage of running continuously, allowing you to see exactly how the light will fall in the finished picture. However, the light has a strong orange content, typically around 3400K, requiring the use of tungsten film or a blue correction filter used either over lens or light for a neutral result. Tungsten lights can also generate enormous heat, making them unsuitable for certain subjects.

Flash heads are more commonly used because they are much cooler to run, produce a white light balanced to standard film stocks, and have a greater light output.

Many studios have both types, and a decision about which to use is based on the requirements of the job in hand.

which accessories when?

Every bit as important as the lights themselves are the accessories that are fitted to them. Very few pictures are taken with just the bare head, as the light simply goes everywhere – which is not normally what's wanted at all. To make the light more directional you can fit a dish reflector, which narrows the beam and allows you to restrict it to certain parts of your subject.

A more versatile option is provided by 'barn doors', which have four adjustable black flaps that can be opened out to accurately control the spill of the light. If you want just a narrow beam of light, try fitting a snoot – a conical black accessory which tapers to a concentrated circle.

Other useful accessories include spots and fresnels, which you can use to focus the light, and scrims and diffusers to reduce the harshness.

If you want softer illumination, the light from a dish reflector can be bounced off a large white board or, more conveniently, especially for location work, fired into a special umbrella.

If that's not soft enough for you, invest in a softbox – a large white accessory that mimics window light and is perfect for a wide range of subjects. The bigger the softbox, the more diffuse the light.

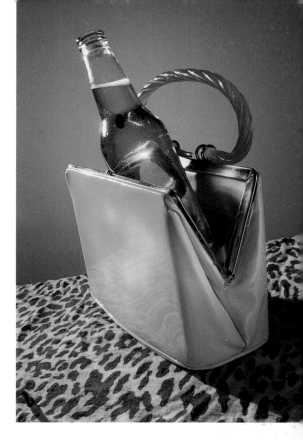

when and how to use reflectors

Reflectors are simply flat sheets of reflective material designed to bounce light back onto the subject. The aim is to control the contrast within a scene by lightening, or 'filling-in', the shadow areas. Ready-to-buy reflectors come in all shapes and sizes, but many professionals prefer to improvise. Large sheets of Formica, card or polystyrene are commonly used, any of which can be cut down to size as necessary.

Folding circular types, using a clever 'twist and collapse' design, are easier to store and move around, and typically available in 30cm, 50cm, 1m or 1.2m diameter sizes. There are also 'professional' panels measuring around 6 x 4ft.

Plain white reflectors are ideal when you want simple fill lighting, while silver versions give a crisp, clear light and gold is ideal when you want to add some warmth.

Most of the time the reflector needs to be as close as possible to the subject without actually appearing in the picture.

a

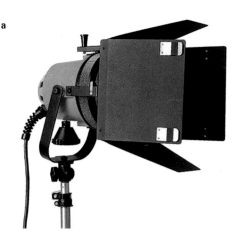

b

Acetate
Clear plastic-like sheet often colour-tinted and fitted over lights for a colour cast

Ambient light
Naturally occurring light

Available light
See Ambient light

Back-projection
System in which a transparency is projected onto a translucent screen to create a backdrop

Barn doors (a)
Set of four flaps that fit over the front of a light and can be adjusted to control the spill of the light

Boom
Long arm fitted with a counterweight which allows heads to be positioned above the subject

Brolly (b)
See Umbrella

CC filters
Colour correction filters used for correcting any imbalance between films and light sources

Continuous lighting
Sources that are 'always on', in contrast to flash, which only fires briefly

Diffuser
Any kind of accessory which softens the output from a light

Effects light
Light used to illuminate a particular part of the subject

Fill light
Light or reflector designed to reduce shadows

Fish fryer
Extremely large softbox

Flash head
Studio lighting unit which emits a brief and powerful burst of daylight-balanced light

glossary of lighting terms
Common and less well-known terms explained.

c

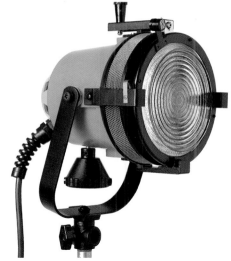

Flag
Sheet of black card used to prevent light falling on parts of the scene or entering the lens and causing flare

Fluorescent light
Continuous light source which often produces a green cast with daylight-balanced film – though neutral tubes are also available

Fresnel (c)
Lens fitted to the front of tungsten lighting units which allows them to be focused

Giraffe
Alternative name for a boom

Gobo (d)
Sheet of black card with areas cut out, designed to cast shadows when fitted over a light

d

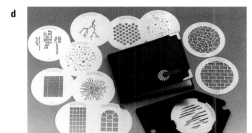

HMI
Continuous light source running cooler than tungsten but balanced to daylight and suitable for use with digital cameras

Honeycomb (e)
Grid that fits over a lighting head producing illumination that is harsher and more directional

Incident reading
Exposure reading of the light falling onto the subject

Joule
Measure of the output of flash units, equivalent to one watt-second

e

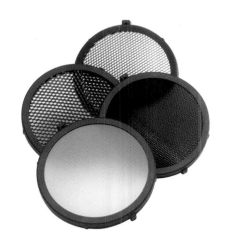

Kelvin
Scale used for measuring the colour of light. Daylight and electronic flash is balanced to 5500K

Key light
The main light source

Kill spill
Large flat board designed to prevent light spillage

Lightbrush (f)
Sophisticated flash lighting unit fitted with a fibre-optic tube that allows 'painting with light'

Light tent
Special lighting set-up designed to avoid reflections on shiny subjects

f

Mirror
Cheap but invaluable accessory that allows light to be reflected accurately to create specific highlights

Mixed lighting
Combination of different coloured light sources, such as flash, tungsten or fluorescent

Modelling light
Tungsten lamp on a flash head which gives an indication of where the illumination will fall

17

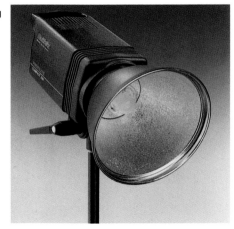

Monobloc
Self-contained flash head that plugs directly into the mains (unlike flash units, which run from a power pack)

Multiple flash
Firing a flash head several times to give the amount of light required

Perspex
Acrylic sheeting used to soften light and as a background

Ratio
Difference in the amount of light produced by different sources in a set-up

Reflector
1) Metal shade round a light source to control and direct it **(g)**
2) White or silvered surface used to bounce light around

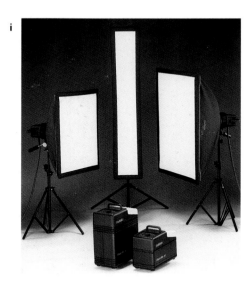

Ringflash
Circular flash tube which fits around the lens and produces a characteristic shadowless lighting

Scrim
Any kind of material placed in front of a light to reduce its intensity

Slave
Light-sensitive cell which synchronises the firing of two or more flash units

Snoot (h)
Black cone which tapers to concentrate the light into a circle

Softbox (i)
Popular lighting accessory producing extremely soft light. Various sizes and shapes are available – the larger they are, the more diffuse the light

Spill
Light not falling on the subject

Spot
A direction light source

Spot meter
Meter capable of reading from a small area of the subject – typically 1–3°

Stand
Support for lighting equipment (and also cameras)

Swimming pool
Large softbox giving extremely soft lighting (see also Fish fryer)

Tungsten
Continuous light source

Umbrella (b)
Inexpensive, versatile and portable lighting accessory. Available in white (soft), silver (harsher light), gold (for warming) and blue (for tungsten sources). The larger the umbrella, the softer the light

practicalities | How to gain the most from this book

The best tools are those which can be used in many different ways which is why we've designed this book to be as versatile as possible. Thanks to its modular format, you can interact with it in whichever way suits your needs at any particular time. Most of the material is organised into self-contained double-page spreads based around one or more images – though there are also some four-page features that look at the work of a particular photographer in more depth.

In each case there are at least two diagrams which show the lighting used – based on information supplied by the photographer. If you want to produce a shot that's similar, all you have to do is copy the arrangement. Naturally the diagrams should only be taken as a guide, as it is impossible to accurately represent the enormous variety of heads, dishes, softboxes, reflectors and so on that are available while using a limited range of diagrams, nor is it possible to fully indicate lighting ratios and other such specifics. The scale, too, has sometimes had to be expanded or compressed to fit within the space available. In practice, however, differences should be small, and will anyhow allow you to add your own personal stamp to the arrangement you're seeking to replicate. In addition you'll find technical details about the use of camera, film, exposure, lens etc. along with any useful hints and tips. The spreads themselves are organised into chapters, each devoted to a specific lighting situation – starting with daylight and increasing in complexity – from one light to multiple-head set-ups.

icon key

- Photographer
- Client
- Possible uses
- Camera
- Lens
- Film
- Exposure
- Type of light
- Model
- Stylist
- Assistant
- Location
- Set
- Make-up

understanding the lighting diagrams

three-dimensional diagrams

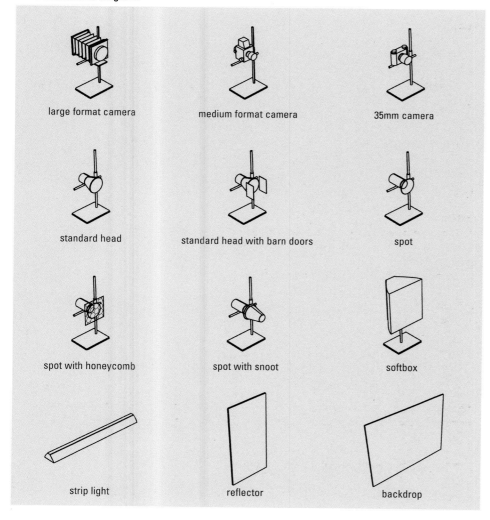

large format camera

medium format camera

35mm camera

standard head

standard head with barn doors

spot

spot with honeycomb

spot with snoot

softbox

strip light

reflector

backdrop

plan view diagrams

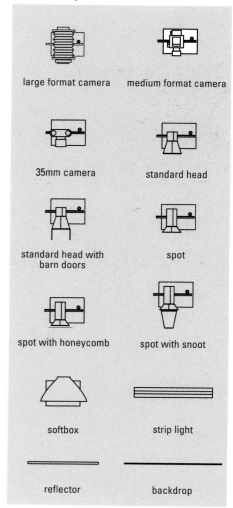

large format camera

medium format camera

35mm camera

standard head

standard head with barn doors

spot

spot with honeycomb

spot with snoot

softbox

strip light

reflector

backdrop

19

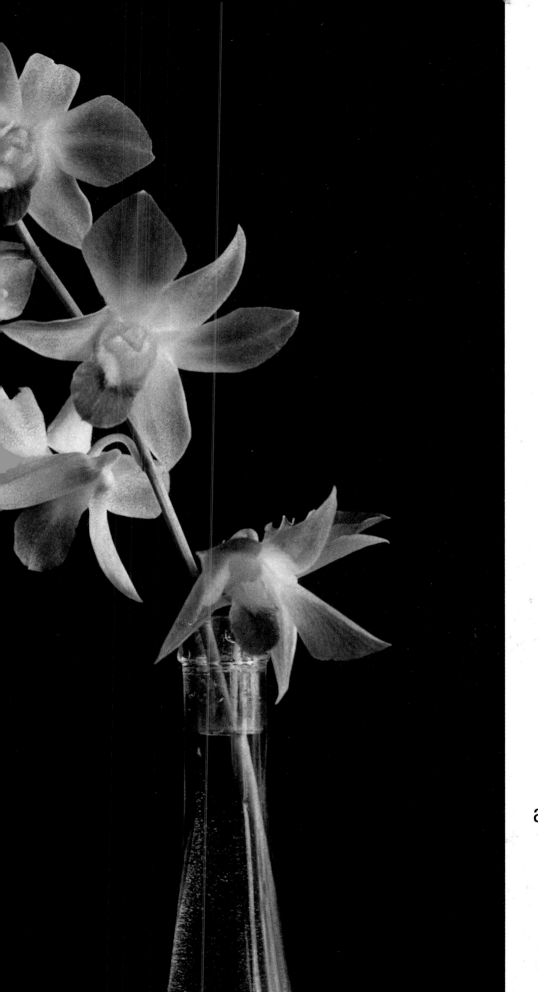

ambient & daylight

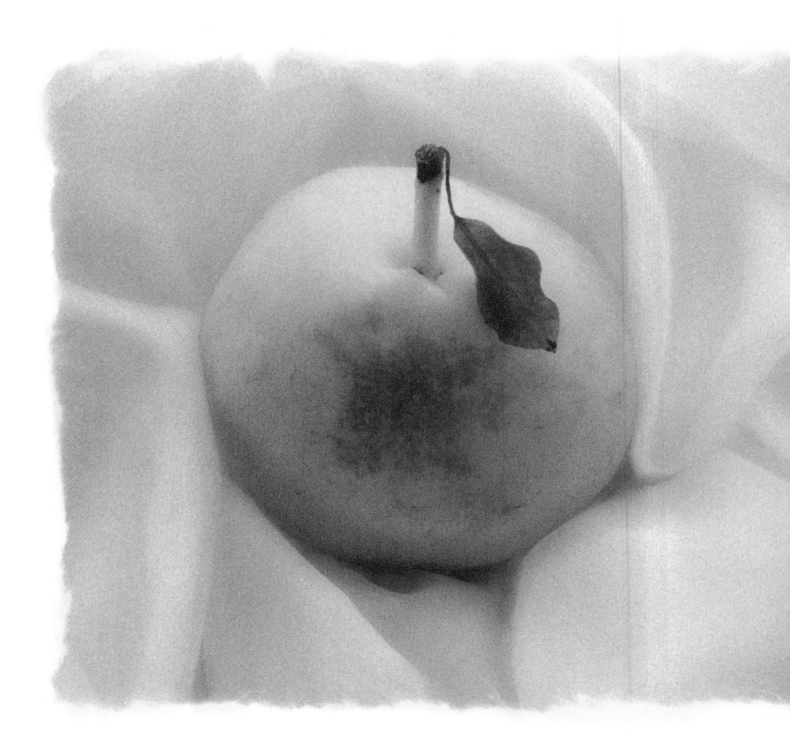

22 **pears on silk**

A large bay window provides sumptuous illumination for a simple but effective still life.

 Kathy Harcom
Exhibition
35mm
50mm macro
Kodak High-speed Infrared
1/30sec at f/22
Daylight

'I took this picture because of the gorgeous, delicate late-afternoon light that was coming in. The pear is on some silk in a box that's resting on the shelf in a large bay window. The sun had been shining, but I waited until it went behind a patch of cloud to give a more diffuse illumination. To enhance the softness even more, I used a black & white infrared film and then hand coloured the resulting print,' says Harcom; 'the light burns out all but the top corners of the frame, and illuminates the model softly and evenly.'

film choice

Black & white infrared film can be an excellent choice for still-life photography; it makes the subject glow, and gives the picture an unusual feel. Good results can usually be achieved by fitting a red filter over the lens and rating the film at ISO400, though bracketing exposures above and below the indicated settings is advisable until the film's characteristics become more familiar.

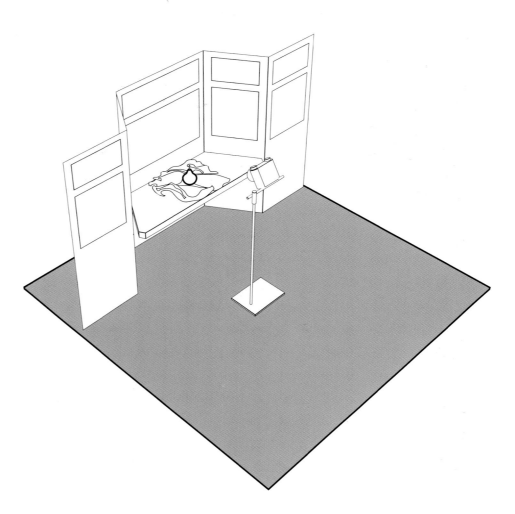

creative edges

Artistic edge effects such as this are easy to do digitally, but they're also not that difficult to create using traditional printing methods. Make a cardboard mask slightly smaller than the negative and layer the two in the carrier when printing, adjust the mask as necessary to achieve the effect you want.

plan view

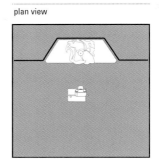

moods for food

The food photography
of Paul Harwood.

Asked to illustrate a series of articles about food around the world, photographer Paul Harwood decided to go for a naturalistic approach. 'I'm a great believer in keeping things simple,' he says, 'and for me nothing beats using real light. You can't simply set things up and snap away, of course, the secret lies in matching the daylight to the subject in hand, as well as supplementing and enhancing it as necessary. The four images shown here depict the cuisines of France, Mexico, Italy and Turkey, and the aim was to create a different mood for each shot by the use of light. Some were taken outdoors, using late evening sun to throw long, evocative shadows and others were captured indoors by means of window light, but all produce graphic compositions with a clean, fresh, contemporary feel.'

plan view

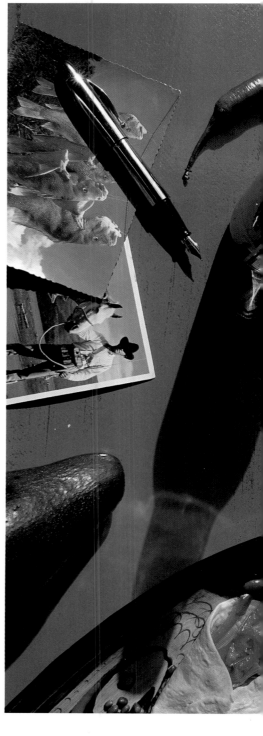

a taste of mexico

The glorious colours and warm tones of this image immediately conjure up exotic locations, while the chillies and tortillas tell you at a glance that the place in question is Mexico. In fact, the picture was taken in the UK, late in the afternoon when the sun was low in the sky, resulting in the long shadows and golden tone. Everything was set up earlier in the day, and the photographer waited until the light was perfect.

The table was painted especially to provide maximum contrast with the reds, yellows and oranges in the set, while the exposure was slightly under to optimise colour saturation.

To prevent the shadows becoming too dark and making the shot look heavy, there were white reflectors to the left and bottom of the set. A helicopter view with a 24mm wide-angle lens in close produces a dramatic and eye-catching perspective.

- Paul Harwood
- Editorial
- 35mm
- 28mm
- Fuji Velvia
- Late-afternoon daylight

italian food

Ham, spaghetti, olive oil, pasta? It could only be Italy. A closer look shows how the image has been made more realistic by the inclusion of a copy of Italian Vogue magazine and the use of an Italian language newspaper as the background, with subtle colouring to reflect the Italian flag.

The light, coming in through a window, is intended to mimic the crisp, clear illumination you get in Tuscany. This is supplemented with a low-powered flash bounced from a sheet of white card to fill in the shadows and prevent them ending up too dark.

- Paul Harwood
- Editorial
- 35mm
- 24mm
- Fuji Velvia
- 1/60sec at f/8
- Late-afternoon daylight

practical tips

* To avoid dark shadows use either flash or reflectors to provide fill-in
* Think creatively about what you can to the set to make it more realistic
* Don't simply repeat the same lighting set-up – vary it according to the subject matter

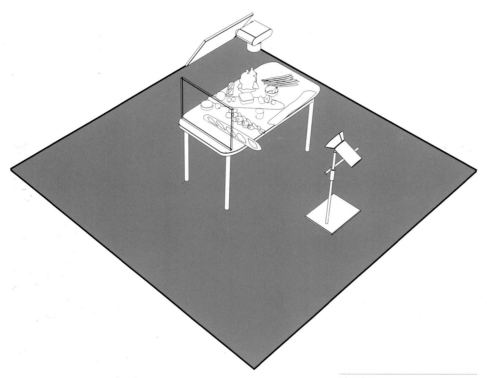

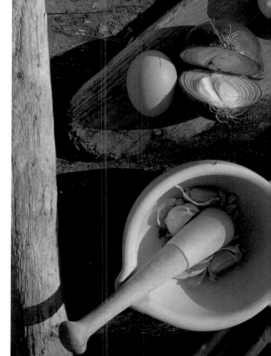

plan view

french farmhouse cuisine

Creating lighting such as this in the studio is relatively straightforward – but why bother when it's all provided for you on a sunny afternoon outside? However, as the sun drops towards the horizon shadows proliferate and become darker, so for this image Harwood bounced a small amount of flash onto a bounce card above the set to give an overall illumination, to control the contrast and to add one or two highlights.

The 'table' was constructed from planks of recycled wood, and the various elements of French farmhouse cuisine were assembled into an appealing composition.

Paul Harwood
Editorial
35mm
28mm
Fuji Velvia
f/8 at 1/60sec
Afternoon light and fill-in flash

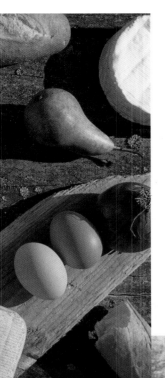

Paul Harwood
Editorial
35mm
28mm
Fuji Velvia
1/4sec at f/8
Window light and slide projector

turkish delight

A soft, light and airy feel was wanted for this 'Turkish' composition, so Harwood decided to combine windowlight indoors with illumination from a slide projector. While the relatively diffuse light of a cloudy day outside entering the window provided the overall illumination, it was the projector that injects the diagonal shaft of light. 'Slide projectors can be versatile lighting tools,' says Paul. 'You can fit home-made snoots over them to control the light, or as in this example, place a sheet of tracing paper in front to create a softbox effect.' Bounce cards to the left and below add the finishing touch.

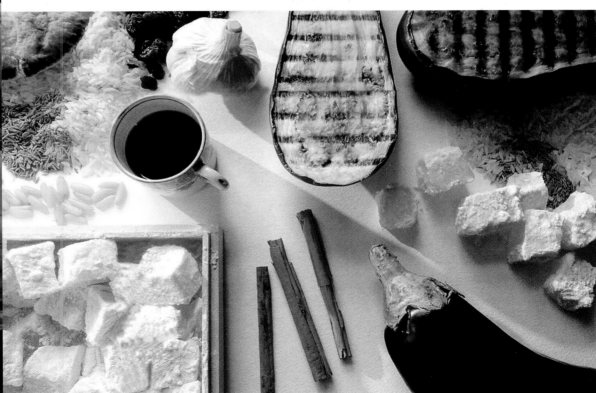

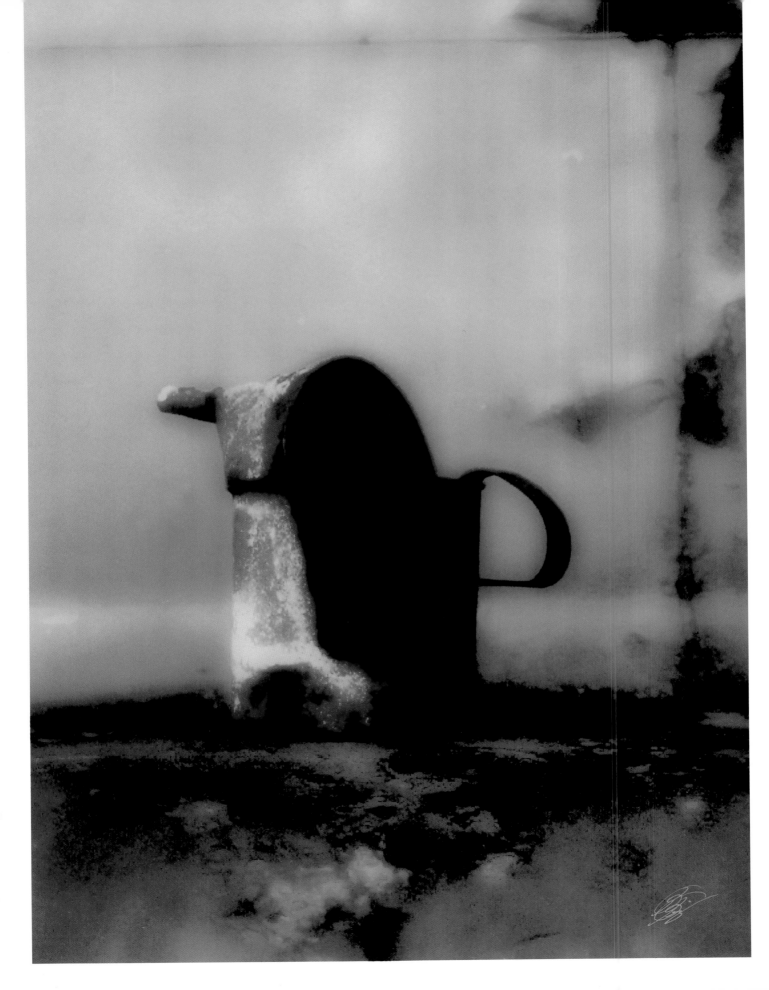

The photographer spotted this old oil can while on location in Norway and thought it would make an attractive still-life composition. He used his favourite lens, a 55mm macro, and took advantage of the natural lighting which was coming in from the left-hand side. This caused the other side of the can to throw deep shadows, these added depth to the image rather than detracted from it. Using reflectors to fill-in the shadows would reduce the contrasty lighting ratio and give more shadow detail, but at the expense of impact. The original green colouring was enhanced digitally in Adobe Photoshop.

- Berry Bingel
- Personal project
- Portfolio
- 35mm
- 55mm macro
- Polaroid Polagraph
- 1/15sec at f/5.6
- Ambient lighting

plan view

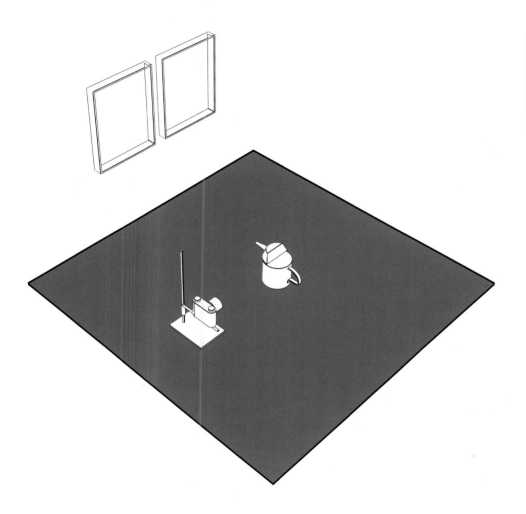

green oil can

29

Directional ambient lighting provides the basis for a dramatic still-life image.

cars on location

The car photography
of Michael Bailie.

'Most pictures of cars on location are taken early in the morning or late in the evening, that's when the light is at its best,' explains Bailie.

'Once the sun has gone down, it's like shooting in a car studio. There's no direct light – it's reflected off the sky like an enormous softbox, giving you a lovely soft light that shows off the body lines beautifully. That's the effect car photographers are trying to achieve. On balance, morning light is better, but less convenient. Whenever possible you want to get everything set up a couple of hours ahead of time, and then wait until the light is right. Sometimes you know when that is and other times you keep shooting till you think it's way too dark, but the shots taken last are the best. The film sees so much more than you do.'

'Generally you want to shoot against the light, to get that sweep of light along the side of the car. It helps to think of the car as a cube, and twist it around until the angle of the light is just right. However, that puts the front of the car in the shade, and you may need to use reflectors or fill-in flash to pick out highlights. In particular, the manufacturer's badge needs to be well lit.'

'Often I'll put the lights on. It's amazing what a difference that can make, especially if you've got a blue or black car. It gives that extra bit of colour, and stops it looking bland. You can also use reflectors to bounce light back from the headlights or, if you have another car, use its headlights for illumination.'

practical tips

* Generally you're looking for some kind of attractive or stylish location, such as sweeping countryside or hi-tech buildings. However, gaining access to such sites is increasingly a problem. Permission is often required and a fee payable
* Cars need to be spotless, especially for brochure and PR shots, always have water and cleaning cloths with you
* Taking a low viewpoint can make a difference between a dull shot and an exciting shot, making the car appear to float in the air
* Be aware of what's in the foreground, for example pebbles or litter can be extremely distracting
* If you're going for differential focus, make sure the front of the car is sharp; like the eyes in a portrait, it's the most important thing
* Be careful when using a polariser as it can bring out the texture of the glass and produce a chequered effect. You may not notice it at the time of taking, but it will be only too apparent when you get the pictures back

plan view

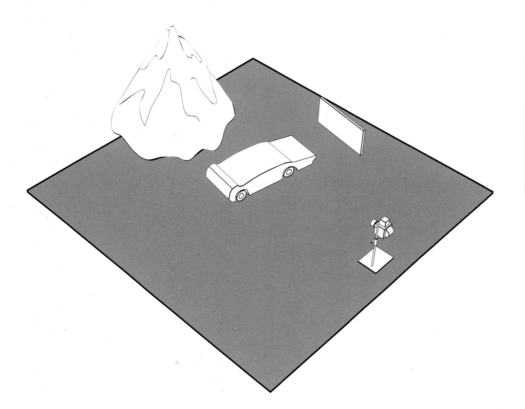

vector

Car photography is often about contrast – and that vivid yellow backdrop really helps the vehicle stand out. In fact it's sulphur, and the colour is entirely natural, with no filters required. Staging the shoot in the evening, though, allows the warmth of the sun to enhance it, as well as producing softer, more pleasing shadows. A large reflector was placed in front of the car, just out of shot, to bounce light back onto the front.

Michael Bailie
Car magazine
Advertorial
6 x 6mm
180mm
Kodachrome 64
1/15sec at f/11
Evening daylight

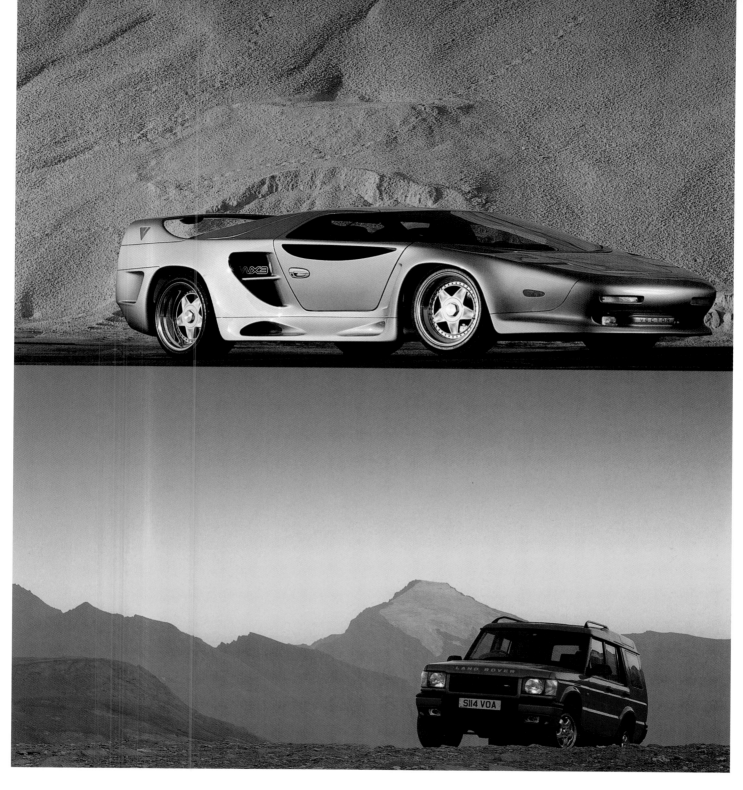

land rover

'This may look like a lonely spot in the Alps – and the perfect place for a 4 x 4, but in fact it was taken from a busy car park with lots of people milling around,' comments Bailie. 'Cars are like mirrors and you have to be careful not to allow unwanted reflections in those type of situations.'

'Waiting until the sun went down meant that many of the visitors had left, and the lighting was also wonderfully atmospheric. To enhance the mood further I used two graduated filters, coral and grey, to darken down the sky. A telephoto lens helped isolate the subject and compress perspective, while switching on the vehicle's lights added the finishing touch.'

Michael Bailie
Car magazine
Advertorial
6 x 7cm
180mm
Fuji Velvia
1 second at f/11
Evening daylight

ford probe

This was part of a large sequence of shots taken for what is known as a 'drive' story for a car magazine. A motoring journalist writes about his experiences in using the vehicle in a particular environment, while an accompanying photographer captures memorable images along the way. This picture was taken during a test of the Ford Probe in California.

Looking for general shots that seemed American, in order to give a flavour of the country, they came upon this railway location and decided it was worth investigating. Because they had been using the car to get around, they quickly cleaned it up and positioned it to take advantage of the setting sun.

Aware that the high-contrast lighting would throw the rear of the car into shadow, and that switching on the lights would not on its own be enough, the photographer added fill-in flash from a portable gun. This was placed just out of shot directly behind the car and fired by means of a radio-controlled remote. Exposure was worked out first for the background, and then the fill-in ratio calculated to give the optimum balance.

(⚲) Michael Bailie
(◔) Performance Car magazine
(◉) Editorial
(▣) 35mm
(◉) 28mm
(▶) Fuji Velvia
(◷) 1/2sec at f/8
(◐) Daylight

plan view

stansted

'Daewoo said they wanted arty shots of their car, so I was looking for a suitable backdrop,' Bailie explains. 'This futuristic building designed by Norman Foster was ideal – although I had to pay a fee to use it as it was on private property. To make the car look as interesting as possible, and to open up the perspective, I got in low with a wide-angle lens.'

'Shooting against the light in this way once the sun has gone down creates highlights in all the right places, but you have to make sure the car is spotlessly clean or you'll end up with lots of retouching. The light glinting on the headlamps was created by means of a folding reflector near the camera, and a grey graduated filter was fitted to balance the sky exposure.'

(⚲) Michael Bailie
(◔) Daewoo
(◉) Promotional
(▣) 6 x 7cm
(◉) 65mm
(▶) Fuji Velvia
(◷) 1 second at f/16
(◐) Daylight

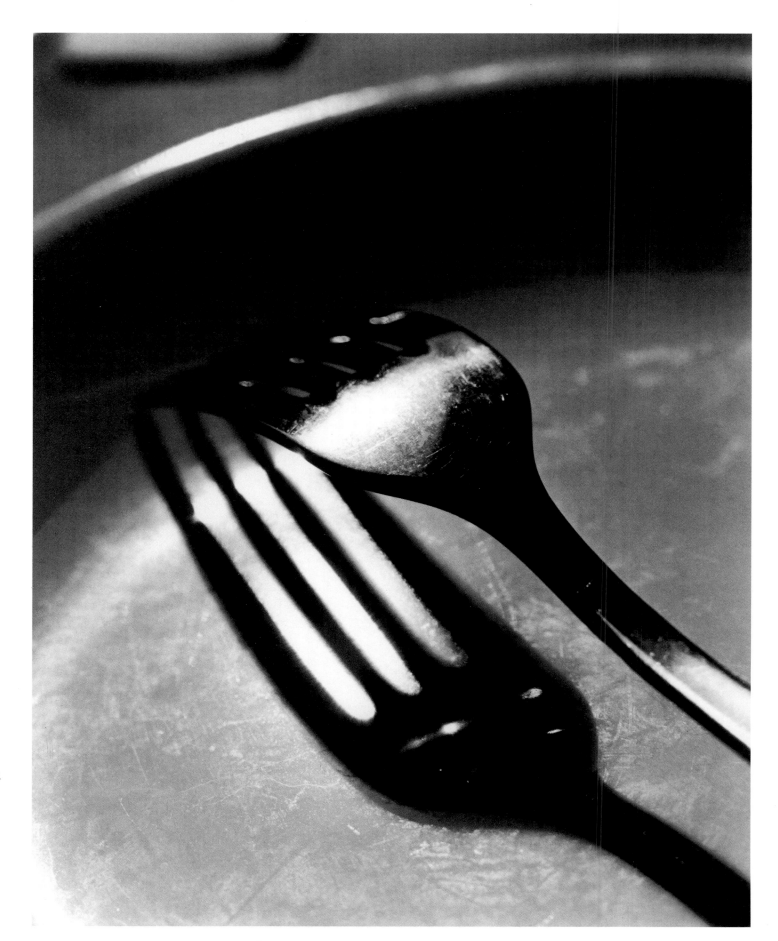

To supplement beautifully-lit studio shots of models wearing shoes for footwear manufacturer Ecco, the photographer spent some time in Paris capturing spontaneous images that could be used for atmosphere. Having stopped for lunch at a streetside café, his attention was caught by this fork on a scratched porcelain plate. Direct overhead sun was throwing deep shadows and creating intense highlights, which careful exposure and skilful printing were able to maintain. 'I didn't want to use reflectors,' says Bjarnhoff, 'because with this kind of photography if you start to mess around with your subject you lose something.'

- Morten Bjarnhof
- Ecco shoes
- Brochure
- Stine Bang
- 6 x 7cm
- 105mm + close-up ring
- Kodak T400CN
- 1/1000sec at f/8
- Daylight

plan view

fork on plate

Bright sunlight was the natural illumination for this found still life.

'This picture was illuminated entirely by natural light. I positioned the vase on a ledge indoors between two windows in a house where I used to live. Tracing paper was placed over the window to soften the light and cut down the amount of light entering,' comments Hyman. 'I tried various positions for the vase until I felt the composition and the shadows were just right.'

'I love to photograph tulips and the way I work is to just put them in a vase and watch how they fall. Often I wait until they start to die and flop a little, since they hang over and make nice shapes.'

practical tips

* Pay attention to the changing nature of light indoors, and shoot when it is at its best
* Place tracing paper over windows if you want to soften and reduce the illumination
* You can use shadows to create a sense of depth and interest in a photograph

(人) Caroline Hyman
(◎) Fine art
(◉) Various
(▣) 6 x 6cm
(◉) 50mm
(▶) Ilford FP4
(◷) Not known
(◉) Ambient indoors

plan view

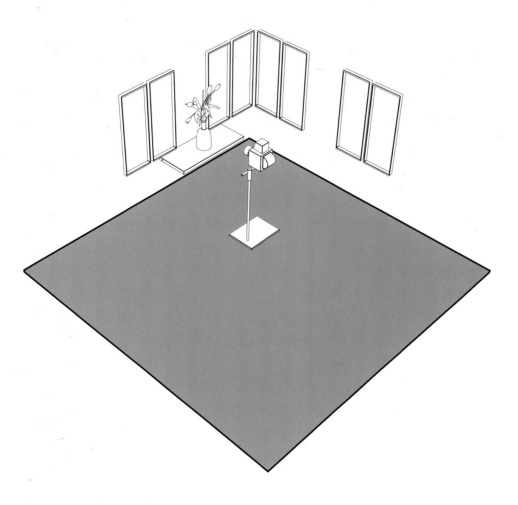

36

vase of tulips

Subtle lighting, delicate printing and careful hand-colouring create a wonderful fine-art composition.

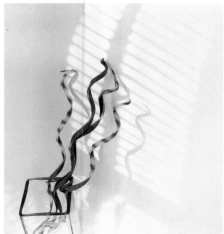

'This picture was taken in my studio, but also using available light – why use additional lighting when daylight can be so beautiful? I noticed the light coming in was casting this shadow through a venetian blind and placed the twisted bark in a place on the floor which took best advantage of it. The print was selenium-toned to make it archival – and I limited the hand-colouring to the bark.'

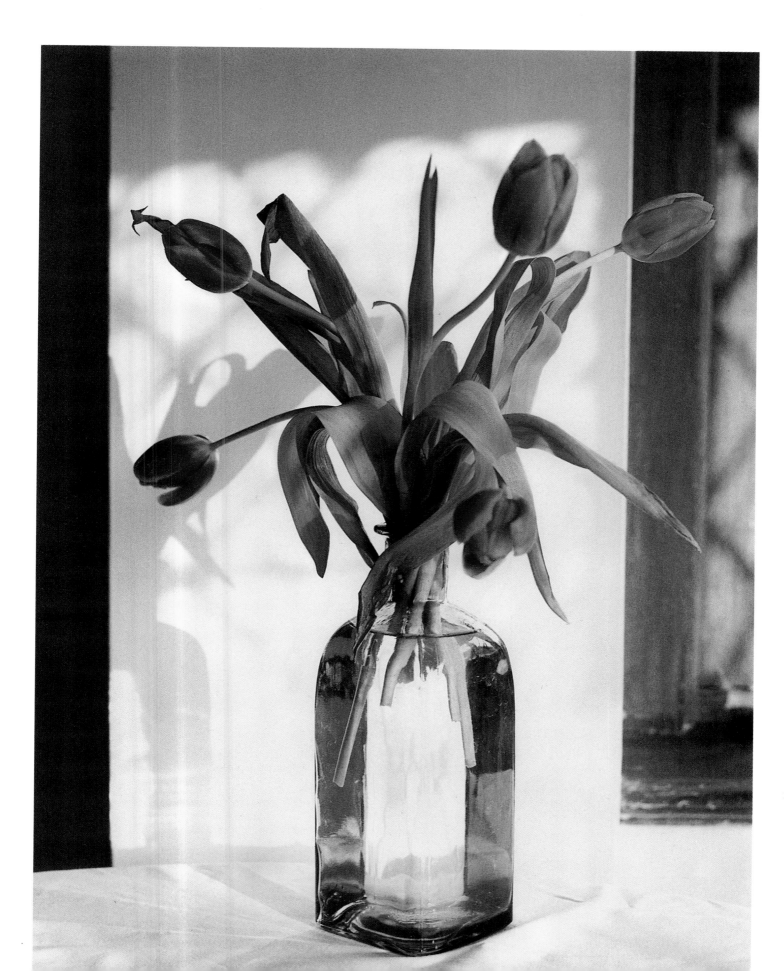

printing for hand-colouring

Prints which you intend to colour by hand should generally be lighter and more delicate – or the finished image may look too dark and heavy. It's best to print onto a matt paper, which absorbs the ink or oil more readily. Preparing the image by sepia-toning first can give a useful base colour.

papers and toning

To maintain the delicate tones Hyman made a light print onto carefully selected artists' paper, which gives the image a sense of being 'etched'. A warm tone developer was used to colour the image slightly and then it was enhanced with a thiocarbamide toner.

film choice

Hyman finds that with high-key images of this type it's better to use a faster film, which has lower inherent contrast and a softer tonality. 'The slightly increased grain also seems to add to the feel,' she adds.

practical tips

* Use a large aperture to give shallow depth of field – this enhances the illustrative feel
* Minimise shadows by using reflectors, such as white walls or background rolls

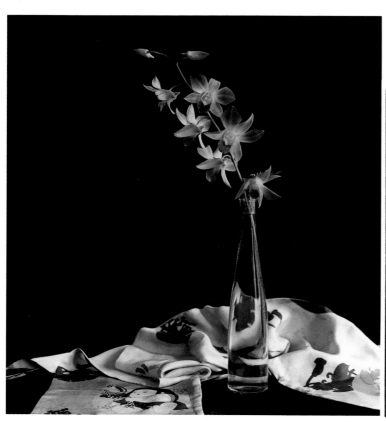

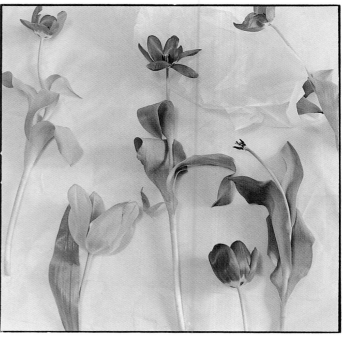

38

'The secret of high-key photography is soft lighting,' reveals Hyman, 'and in the photograph of glass bottles I combined the light coming into the studio from two windows to the left with a 60cm square softbox positioned just over my right shoulder. Although it was an electronic flash head, I used the modelling lights as a continuous light source to make it easier to judge when the balance was just right.'

'You also need to make sure that the subject is as light as possible, the bottles are resting on a white sheet placed over my still-life table with a white background paper roll behind. The sheet and background also act as reflectors, reducing the shadows further.'

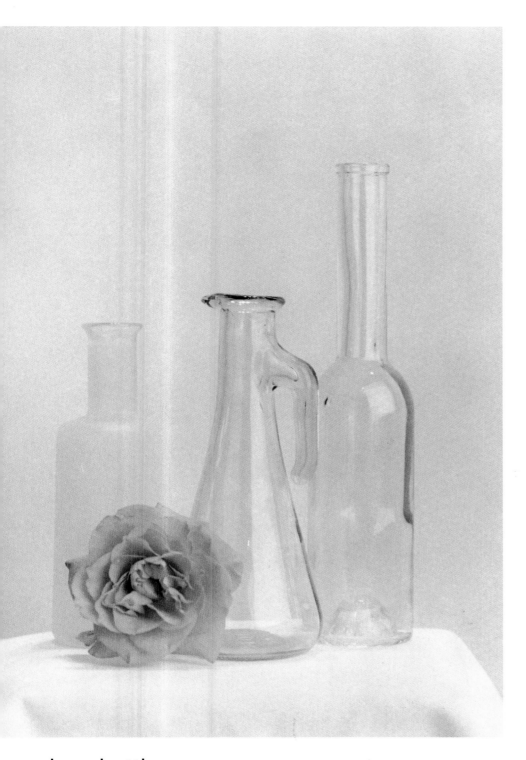

⊛ Caroline Hyman
⊜ Fine art
⊜ Various
⊛ 6 x 6cm
⊜ 80mm
⊜ Ilford HP5
⊜ Not known
⊜ Ambient indoors

plan view

glass bottles

This lovely high-key image was created by balancing window light and a continuous light source, and by delicate printing and toning.

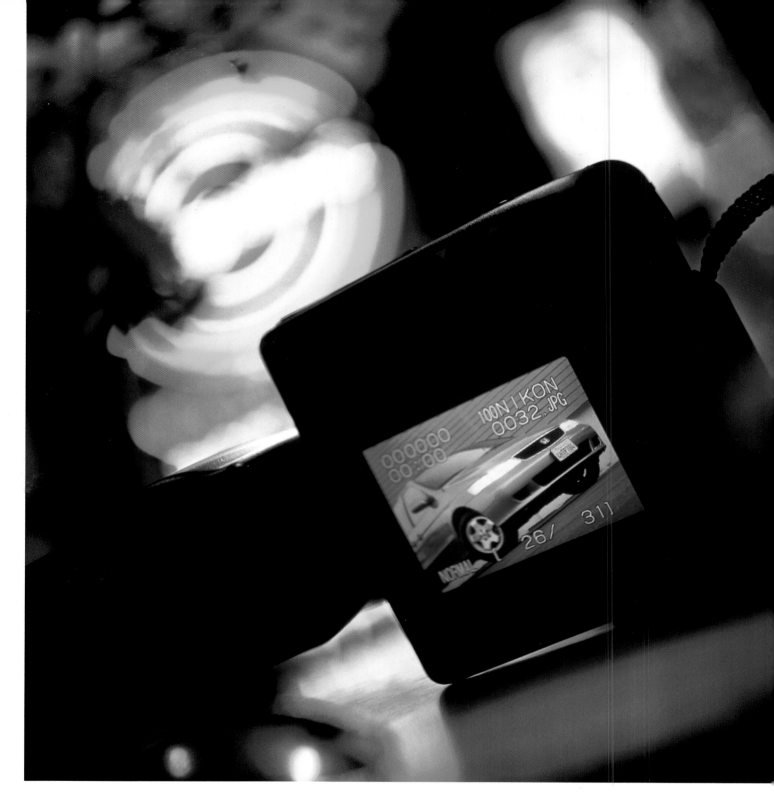

lcd image

Imaginative use of neon lighting and an LCD panel results in an image with a difference.

Commissioned to create a striking image to head up Automobile magazine's '10 Favourite Cars of the Year' feature, Tim Andrew came up with this eye-catching and original idea. He'd been thinking about buying a digital camera for some time, and this shot finally gave him the impetus to do so.

The first stage was to capture the photograph of the Honda Odyssey, this was relatively straightforward as Tim is an experienced car photographer. He then needed to find a suitable location for the final image – one which had bright neon lights outside but was relatively dark inside, this was essential to avoid reducing the contrast of the digital camera's LCD monitor.

The ideal location turned out to be an ice-cream parlour. The digital camera is resting on a table, with a wide-angle lens set to maximum aperture to throw the background out of focus.

🚶 Tim Andrew
🌀 Automobile magazine
👁 Editorial
📷 6 x 7cm
◉ 60mm
▶ Fuji Velvia
🕐 f/5.6 at 1/4sec
💡 Ambient

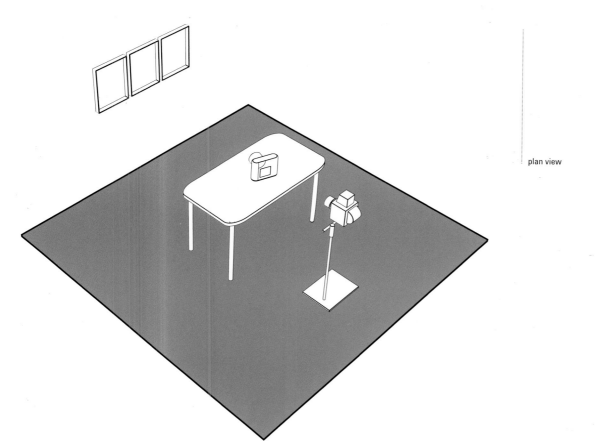

plan view

41

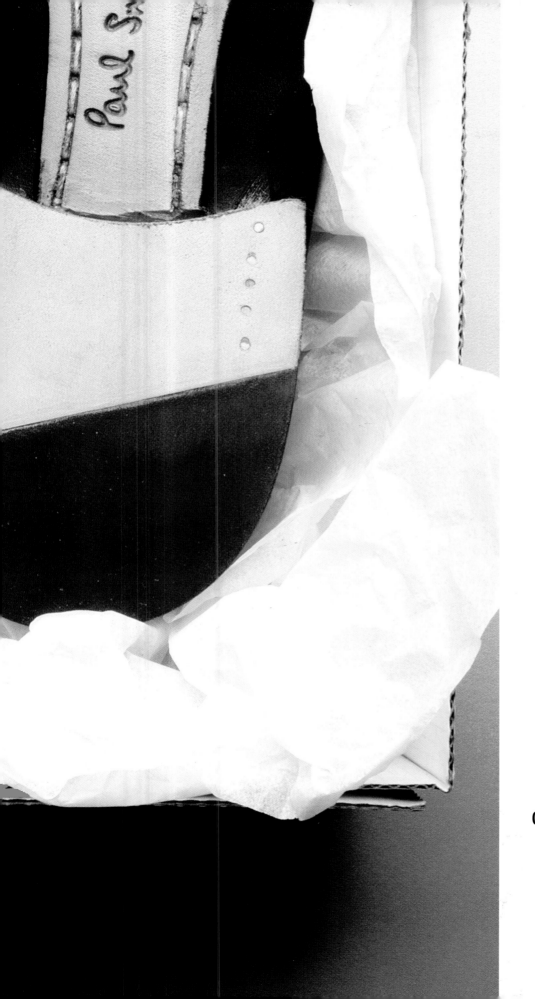

one light wonders

orange clarinet

Backlighting plus long, thin reflector strips bring this clarinet to life.

Xavier Young says, 'I wanted to make this plastic clarinet look architectural, like an oil refinery or a famous building, and decided that going in close was the best approach. 1m behind the clarinet is a large sheet of perspex, and behind that is a flash head in a standard reflector with a strong orange gel fitted. I put the head 2m back to get an even pool of light coming through the perspex. To kick a little detail into the keys, I cut two thin strips of white card and taped them to stands placed as close as possible without them appearing in the shot.'

practical tips

* To avoid dark shadows use either flash or reflectors to provide fill-in
* Think creatively about what you can do to the set to make it more realistic

⊛ Xavier Young
⊘ Random Technologies
◉ Brochure
⊞ 5 x 4 inch
◉ 150mm
▶ Fuji Velvia
⊙ 1/60sec at f/32
⊙ Electronic flash

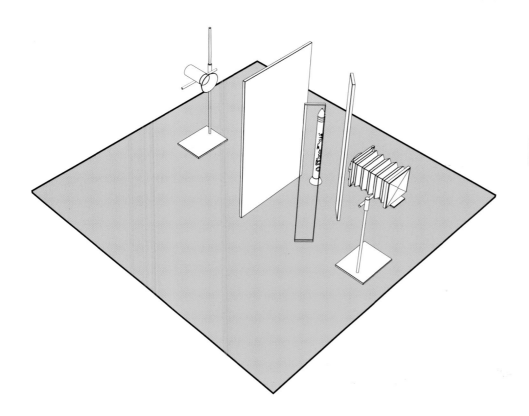

plan view

The standard pack shot for the brochure was lit with a single strip light to the left. There's no fill-in whatsoever.

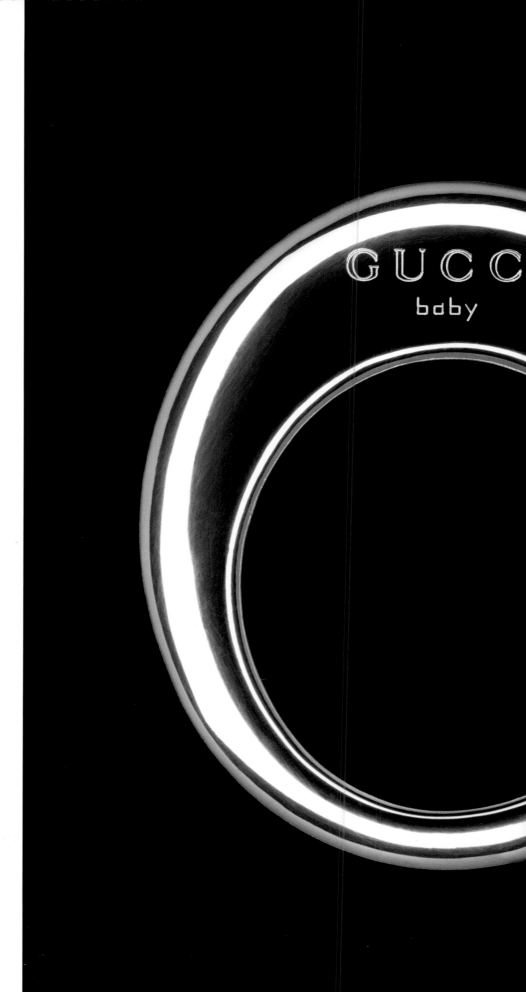

gucci baby rattle

Creating a circular reflector from card helps define a reflective subject.

Unless you knew what this object was you'd probably find it hard to guess – or even to gain any sense of how large or small it is. The product is a Gucci baby rattle, around 5 inches across. It's silver-plated and therefore highly reflective, and because the brief was to photograph it against black, this presented a real challenge. It was essential that the whole of the circumference be lit, so that its shape was clearly defined. The solution was to use a ringflash – with a home-made circular reflector that went all the way around the outside. This was made out of semi-silvered card, and positioned as close to the rattle as possible without being seen in the shot.

🚶 Louisa Parry
🦢 Arena magazine
🎯 Editorial
📷 5 x 4 inch
◉ 210mm
▶ Fuji Velvia
🕐 1/125sec at f/32
💡 Ringflash

plan view

47

coloured plastic cups

Simple lighting is sometimes the most successful solution to a lighting problem.

'Whilst working on a series of promotional shots to demonstrate my appreciation of colour and lighting, I came across these colourful and inexpensive beakers,' Stone says. 'I was interested in the way in which parts of them were translucent and parts were dark when grouped together and lit with a strong light. I tried various compositions and came up with this one.'

'I wanted the photograph to look dynamic so I went for dramatic lighting. There's just one light at a low angle supplemented by a reflector and there's a mirror on the other side to create balancing highlights. Because an 800 watt tungsten light source was used with daylight-balanced film I fitted a blue gel over the head to compensate.'

'It's a simple table-top set-up on a black velvet base so no light is reflected back. I moved the cups around until the light and shadow areas looked right. To add to the impact, I used extensive camera movements to distort the subject, and an aperture of f/8 to limit the depth of field.'

(person)	Alan Stone
(project)	Personal project
(use)	Portfolio
(format)	5 x 4 inch
(lens)	90mm
(film)	Kodak Ektachrome 100VS
(exposure)	1/80sec at f/8
(lighting)	Tungsten lighting

plan view

practical tip

* Black velvet is an excellent base for still-life shots where you want to control the lighting fully

Graeme Montgomery finds that as far as possible he likes to keep things simple on the lighting front, saying; 'for this shot I used just one softbox. I remember hearing someone say "there's only one sun", and that's stuck with me. The softbox was placed just to the right of the aubergine, which is resting on a table-top on a piece of Blu-Tak to stop it toppling over. The 'ghost' image was created simply by moving the camera closer and taking a second exposure on the same sheet of film.'

Ⓐ Graeme Montgomery
Ⓢ Mark Whittaker
Ⓐ Advertising campaign
Ⓐ 6 x 6cm
Ⓐ Kodak Plus-X
Ⓐ 1/60sec at f/8
Ⓐ Studio
Ⓐ Electronic flash

plan view

50

double aubergine

Double exposure and simple lighting combine to produce a memorable image.

bang & olufsen

Stark lighting with strong shadows gives this type of equipment a sharp, clean look.

When Morten Bjarnhof started photographing Bang & Olufsen products, he decided to go for a stark and simple approach. In the past they had often been shown with lots of different props, but he felt that was unnecessary as the products were more than attractive enough to stand on their own merit. From the beginning he wanted whenever possible to use just one light – and he has remained true to his word in a large proportion of his work for the company.

This image is typical of his dramatic, stylised and effective lighting. There's just one spotlight way over to the left – around 7m away – throwing long, dark shadows. These link the various elements together, and are an essential part of the concept. This light was supplemented by two reflector boards bouncing light back into the shadow side. The distance from the light also means there is little or no fall off of light across the picture, although the white has been cleaned up and all cables removed in the production of this finished image.

- 🕴 Morten Bjarnhof
- Bang & Olufsen
- Brochure
- Stine Bang
- 5 x 4 inch
- 150mm
- Kodak EPN
- 1/60sec at f/32
- Electronic flash

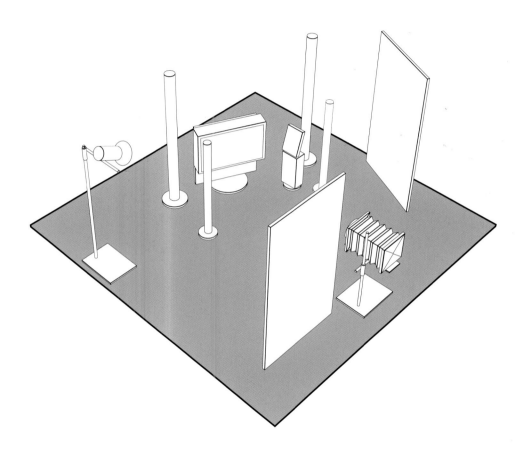

plan view

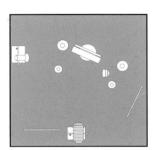

combining two images

53

Morten wanted a reflection in the top right corner of the television, but this was complicated as a board placed in the optimum position would be seen by the camera. The answer was to take two pictures, one of the whole set-up without the reflector, and one with everything but the television taken away, and the reflector in place. The two were then combined in the computer. Because of the distance from the light to the subject, and the need for a small aperture, the flash head was fired 15 times to give the required exposure.

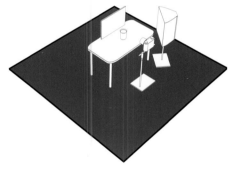

plan view

abstract glassware

Even lighting from a single softbox is all that is needed for successful shots of small glass subjects.

Berry Bingel says, 'it's not easy to identify these subjects at first glance, other than being something scientific or medical. They're actually a laboratory funnel and beaker which I photographed standing on a small table. The abstract treatment means they can be used in lots of different ways as stock images.'

'Only one light was used; a 60cm square softbox about 0.5m from the glassware. You need shadows to outline the shape of the subject, but working this way means they are not too heavy.

- Berry Bingel
- Personal project
- Portfolio
- 35mm
- 55mm macro
- Polaroid Polachrome
- 1/15sec at f/5.6
- Electronic flash

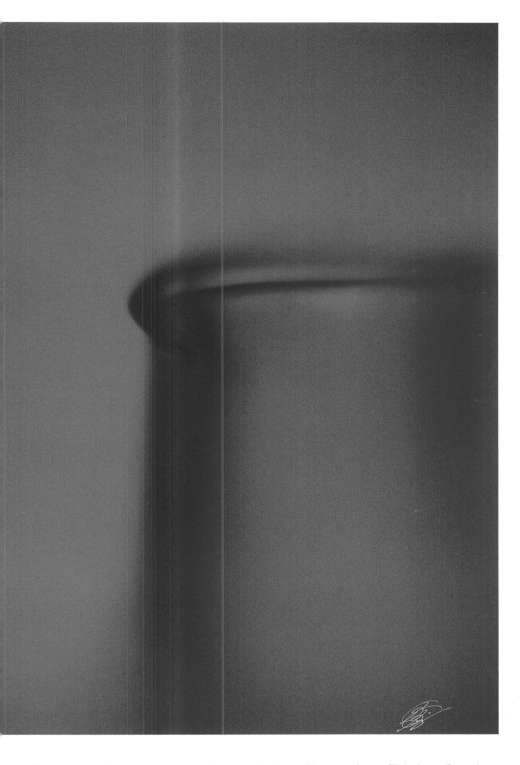

practical tips

* 'I was just playing around to see what happened when I produced these shots. You don't have to be trying to produce a masterpiece every time you take a picture.' comments Bingel
* With small table-top subjects such as these you don't need big background rolls – an inexpensive sheet of A4 or A3 card available from an art shop is more than sufficient
* Going in close with a macro lens and shooting at f/5.6 means the depth of field is extremely narrow

'The beaker and funnel are extremely small, so I went in close with a macro lens to fill the frame. By setting a large aperture I was able to limit the zone of focus for a more interesting and abstract composition.'

'The background in each case consists of pieces of coloured card leaning against another beaker. Because they're 0.3m behind and I used a wide aperture, they're completely out of focus and all you get is the colour.'

'The resulting Polaroid slide was then scanned in, the image was softened and some of the colours changed digitally using Adobe Photoshop.'

Berry Bingel
Personal project
Portfolio
35mm
55mm macro
Polaroid Polachrome
1/15sec at f/5.6
Electronic flash

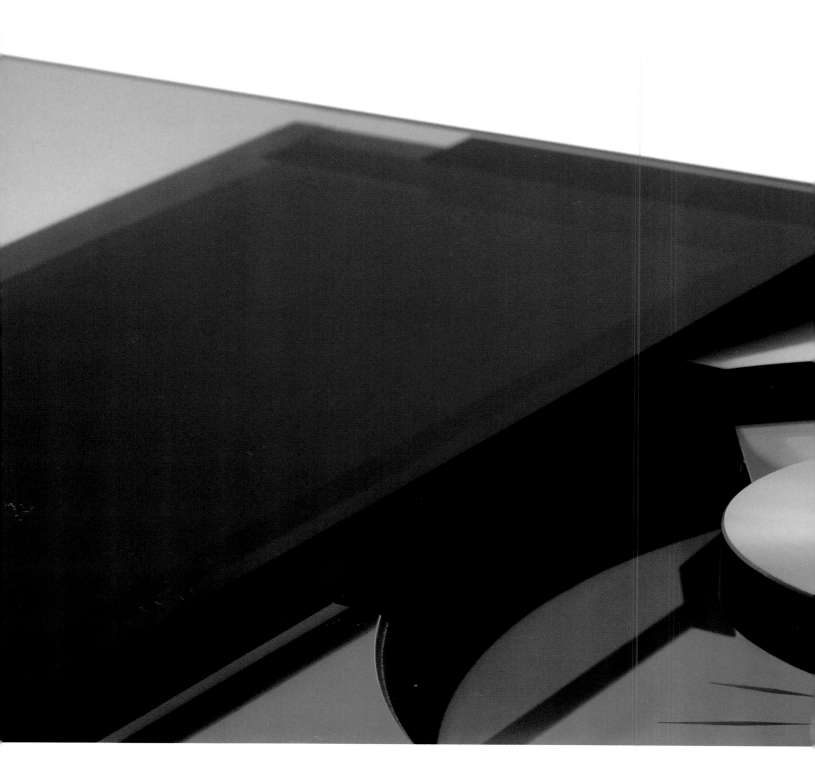

bang & olufsen close up

Small reflectors supplement a single spotlight for shimmering highlights.

- Morten Bjarnhof
- Bang & Olufsen
- Brochure
- Stine Bang
- 5 x 4 inch
- 150mm
- Kodak EPN
- 1/60sec at f/32
- Electronic flash

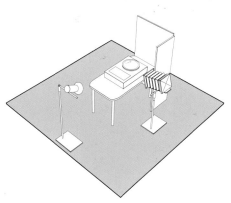

Because Bang & Olufsen products are built and finished to such a high standard, it's possible to go in very close for impact. For this detail shot, the lighting could not have been simpler: a spotlight 2m to the left picks up the sheen of the product, while two white Formica reflectors on the right and to the front create shimmering highlights that contrast wonderfully with the depth of the shadows. Had it been necessary, the white background could have been lit separately, but in fact a clean computer cut-out had been planned.

plan view

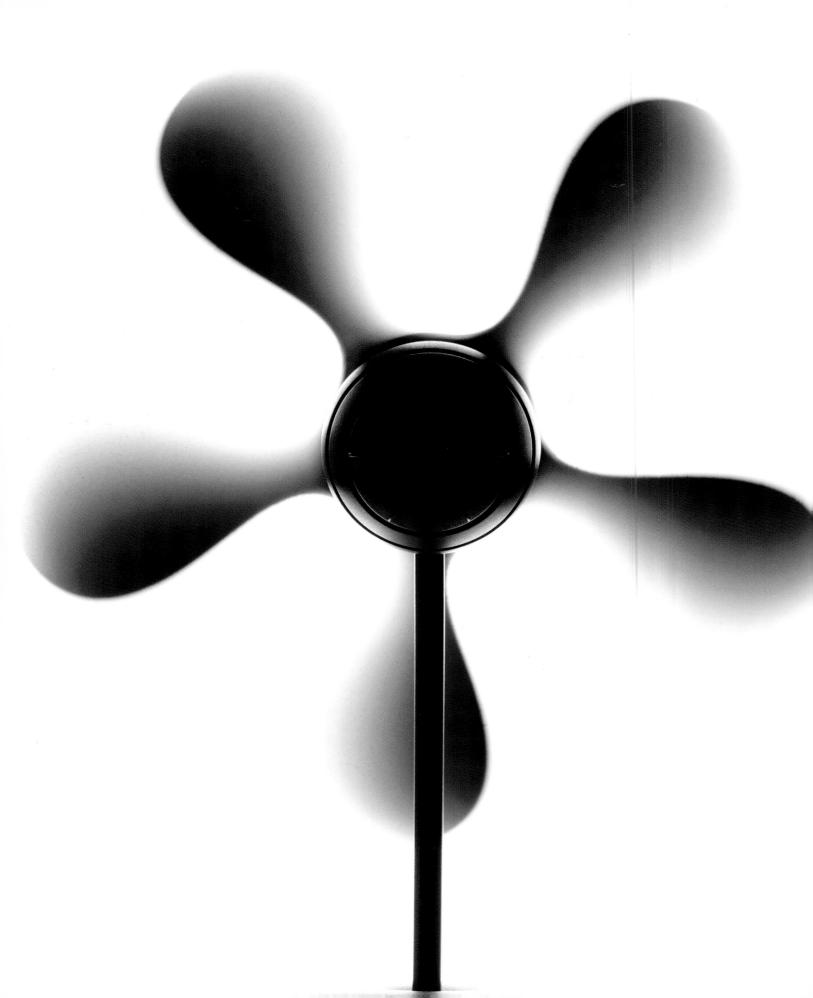

'This fan looks very different in real life to how I've depicted it in the photograph.' Parry describes the set-up further, 'in fact it's silver and made of foam, which is why there's no cover around it for protection. It looks dark because it's purely backlit – there's absolutely no front lighting at all. Behind the fan is a large sheet of perspex and behind that there's a large softbox.'

'I started by taking pictures of the fan stationary, but it looked really boring. So I set it in motion at its highest setting. The modelling on the blades arises from the fact that the fan was moving faster than the flash could freeze, therefore there's a slight amount of blurring. Had I wanted a greater sense of movement I would have used tungsten to light it.'

'It took around ten shots to get the blades just where I wanted them. Having one behind the upright helps gives the image a greater sense of depth. Despite the monochrome feel, it was colour transparency film that I used, with an 81 series filter over the lens to produce the brown tonality.'

ⓧ Louisa Parry
◔ Personal project
◉ Portfolio
▦ 5 x 4 inch
◍ 210mm
▣ Fuji Velvia
○ 1/125sec at f/64
◎ Electronic flash

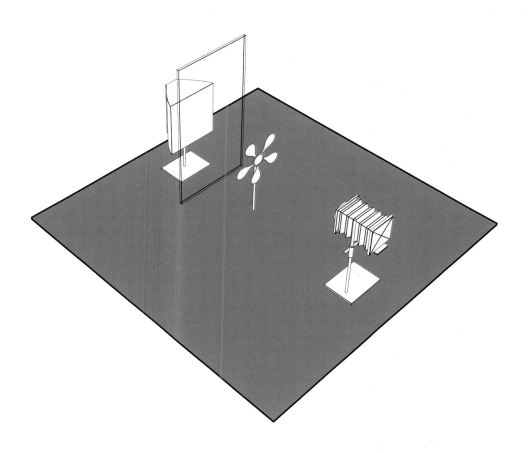

plan view

moving fan

Capturing a fast-moving subject with flash results in an intriguing image with just a hint of blur.

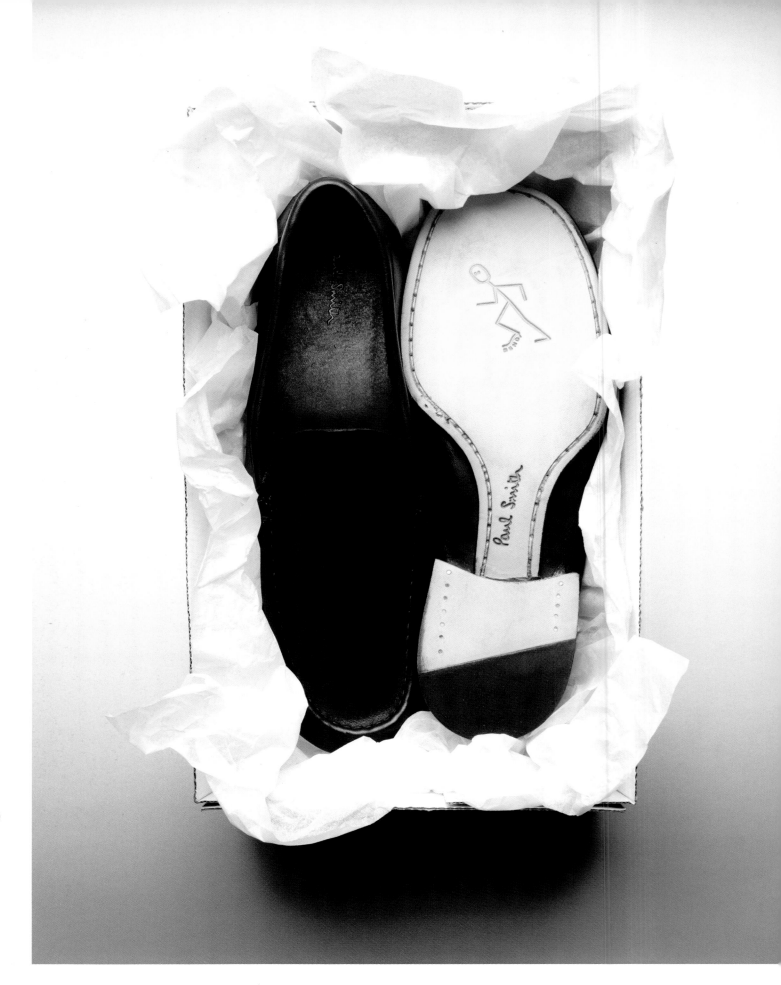

With that hot spot of light in the middle, this photograph looks as if it was lit from underneath as well as from above. In fact there was only one light, angled down at 45 degrees. The burnt out area was created using a clever but inexpensive technique. The key is a sheet of semi-silvered material called Silvercard, which is placed below the semi-translucent sheet of blue coloured plastic. As the light from above hits it, so it reflects it back upwards. The light from the softbox has been softened further by placing a sheet of perspex in front of it, and there's a large mirror used to bounce light back into the shadow side. This last technique is much more controllable option than using a second light.

Louisa Parry
Portfolio
5 x 4 inch
210mm
Fuji Velvia
1/125sec at f/64
Electronic flash

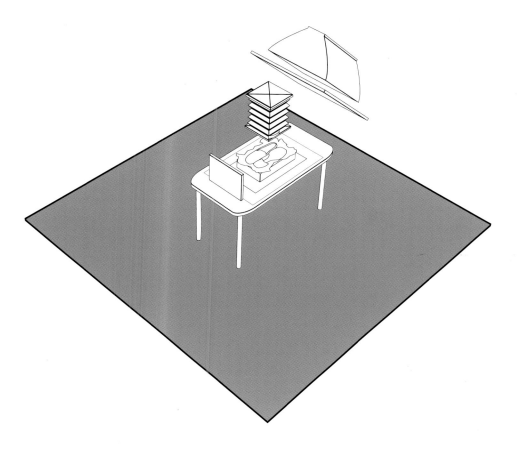

plan view

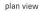
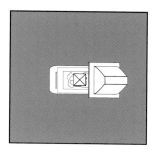

pushing film

'I tend to push Fuji Velvia to ISO80, rather than use it at its recommended speed of ISO50, which boosts the colour and the contrast,' Parry explains.

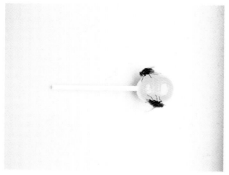

paul smith shoes

Placing the subject on top of silvered card produces a more interesting background.

The lighting set-up used for this intriguing shot was virtually the same as for the shoes. Green plastic was used instead of blue and the mirror was smaller in size. The flies were real, bought from an insect supplier.

Graeme Montgomery comments, 'a lot of the things I photograph are made of metal, so reflections are a real problem. The more lights you use, the more you've got to worry about, I generally I stick to just one light, sometimes using reflectors. I only tend to use more lights when there are different elements in the foreground or background as well.'

It's important in still-life photography to highlight any key features, and here, because this is a Millennium watch, it's the red dot at midnight which is one of the most crucial elements. In terms of lighting, it's easy to see that the light is coming from behind, from a softbox angled down at 45 degrees.

(Graeme Montgomery icon) Graeme Montgomery
(Dunhill icon) Dunhill
(Promotions icon) Promotions
(format icon) 5 x 4 inch
(lens icon) 150mm
(film icon) Fujichrome Provia 100
(exposure icon) 1/60sec at f/16
(light icon) Electronic flash

plan view

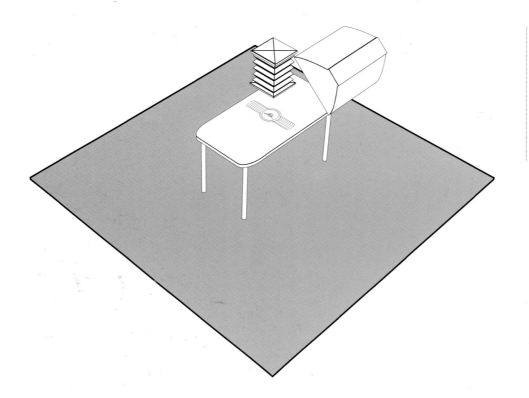

wristwatch

With metallic subjects you don't have to be afraid of reflections – just use them well.

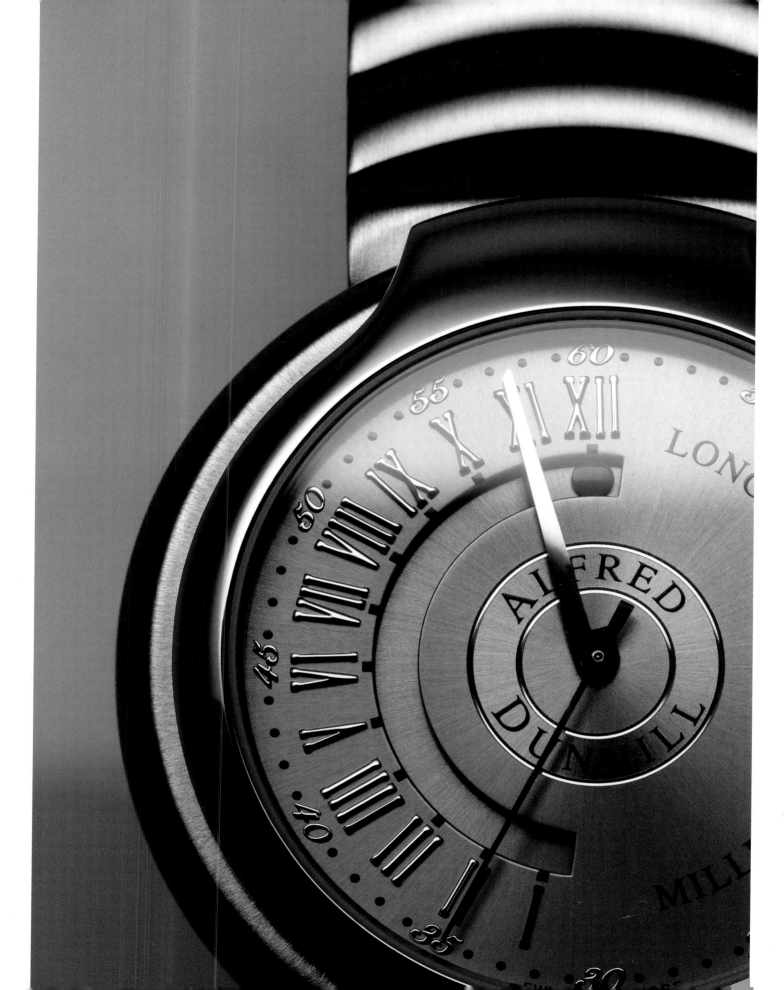

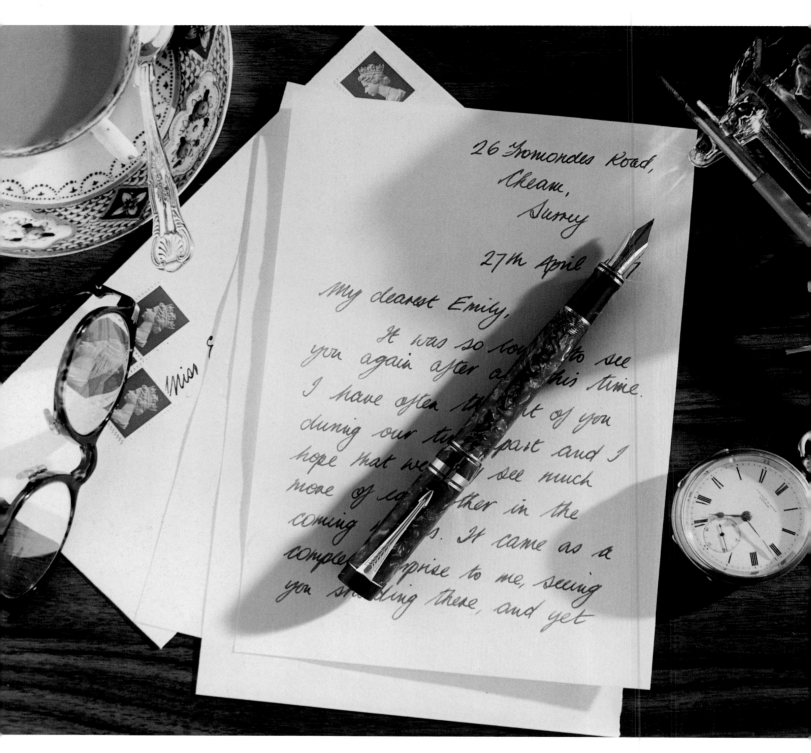

colour on black & white

Using studio flash to recreate evening window light is the starting point for a clever way of combining colour and black & white in a single image.

'I wanted to have a photograph in my portfolio that demonstrated my ability to combine black & white and colour in the same image without using digital imaging,' Glanville comments.

'I began by photographing the set-up in black & white, and then produced a life-size monochrome print. To make sure the print was absolutely true to life, I placed a ruler at the edge of the frame which has been cropped out in the final image. I sepia-toned the print and mounted it on board so it was nice and flat. I then placed the real pen over the black & white image of the pen, and re-photographed the print in colour.'

'Obviously I had to take great care with the lighting. The aim was to simulate late-evening sunlight coming in through a window. I used a single light low down, with a reflector on the other side to soften the shadow. The light itself was an electronic flash head with a standard reflector, positioned about 4m from the set.'

'When I re-photographed the pen I placed the lights in exactly the same place, so the shadow from the real pen fell in the same place as the shadow on the monochrome print.'

Colin Glanville
Personal project
Portfolio
6 x 7cm
240mm
Fujichrome Provia 100 and Ilford FP4
1/60sec at f/16
Electronic flash

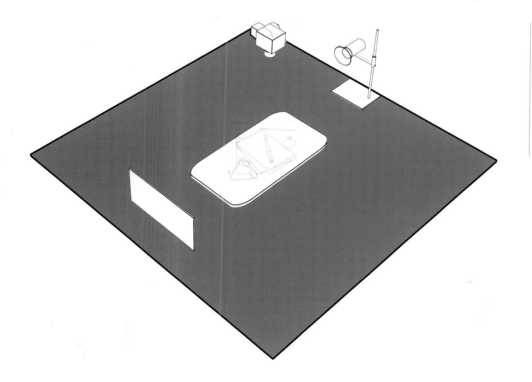

plan view

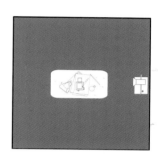

practical tips

* You can create convincing desktop sets using adhesive plastic covering
* Large sheets of cards from an art shop can be used effectively as reflectors

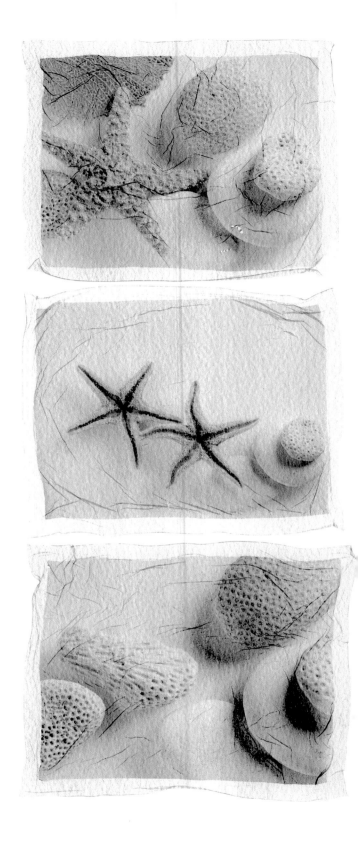

seaside compositions

A single 'balloon' light source gives a lighting effect similar to overcast daylight. Elements can be moved around to create a range of different compositions.

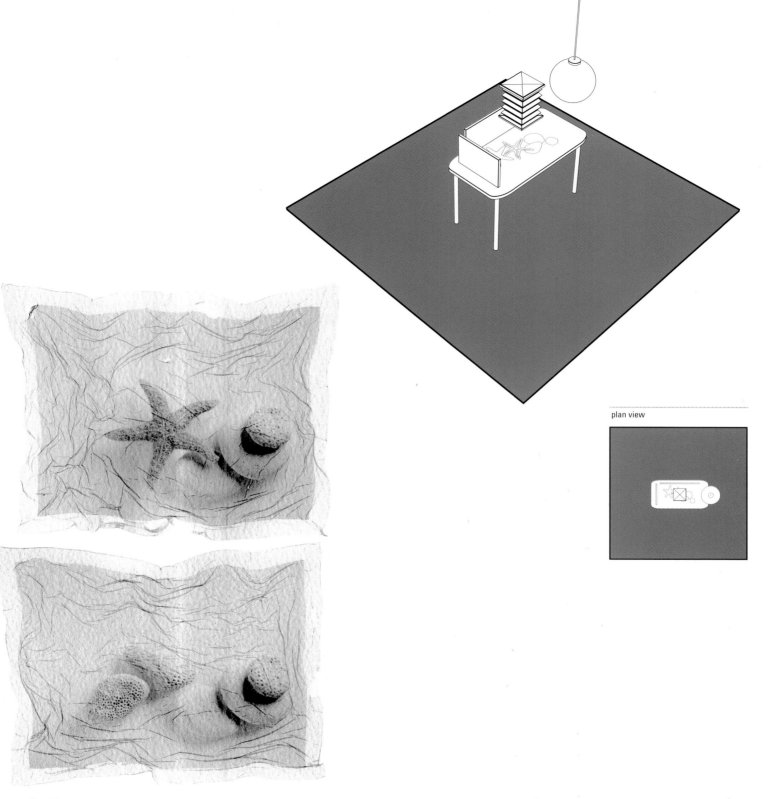

'For this shot I used just one special light,' Innes explains, 'a big white sphere called a Broncolor balloon, this gives an extremely soft light, but with a different feel from that which you get from a softbox. Pictures taken with the light have the most beautiful, luminous quality, similar to that which you get on an overcast day.'

'The camera is looking directly down on the set, which is actually very small, with the light and two reflectors on a table 0.5m from the ground. The picture was taken on Polaroid Type 59 film, and I lifted the emulsion in boiling water and put it onto artist's A5 cartridge paper. I then dried it out and flattened it in a press.'

plan view

- Ivor Innes
- Personal project
- Portfolio
- 5 x 4 inch
- 150mm
- Polaroid Type 59
- 1/30sec at f/11
- Broncolor studio lighting

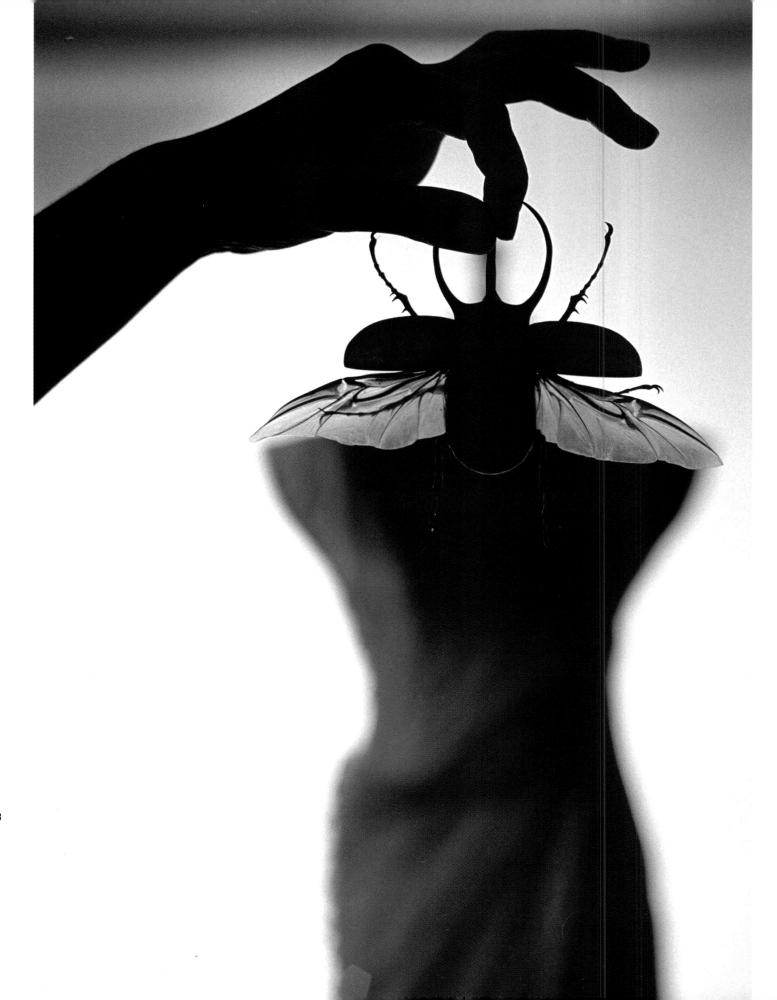

Graeme Montgomery took this photograph as part of an advertising campaign for a fashion designer. He explains, 'the collection was called "Black", and the inspiration was loosely oriental. The hand is holding a stuffed bug, which we got from a taxidermist, and there's a dress on a mannequin about 3m behind. There's only one light, which is illuminating the background from the left, with a white board on the right-hand side to bounce some of it back in. The exposure was set to silhouette the subjects, with just a small piece of card close to the camera reflecting back enough light onto the wings to reveal some detail. The use of a slightly telephoto lens and a medium aperture limits the depth of field.'

- Graeme Montgomery
- Mark Whittaker
- Advertising campaign
- 6 x 6cm
- 150mm
- Kodak Plus-X
- 1/60sec at f/8
- Electronic flash

plan view

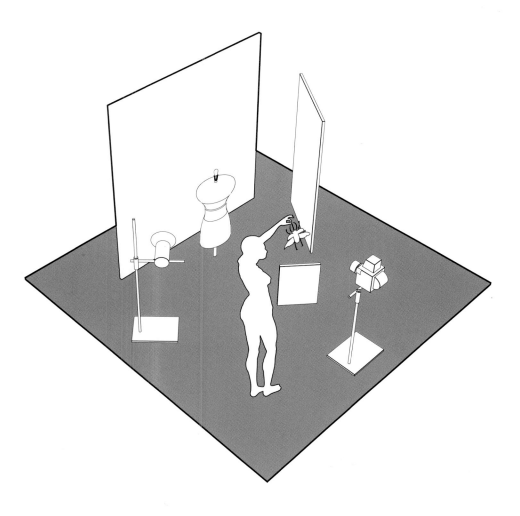

stag beetle

Illuminating the background allows the foreground subject to be rendered as an evocative silhouette.

69

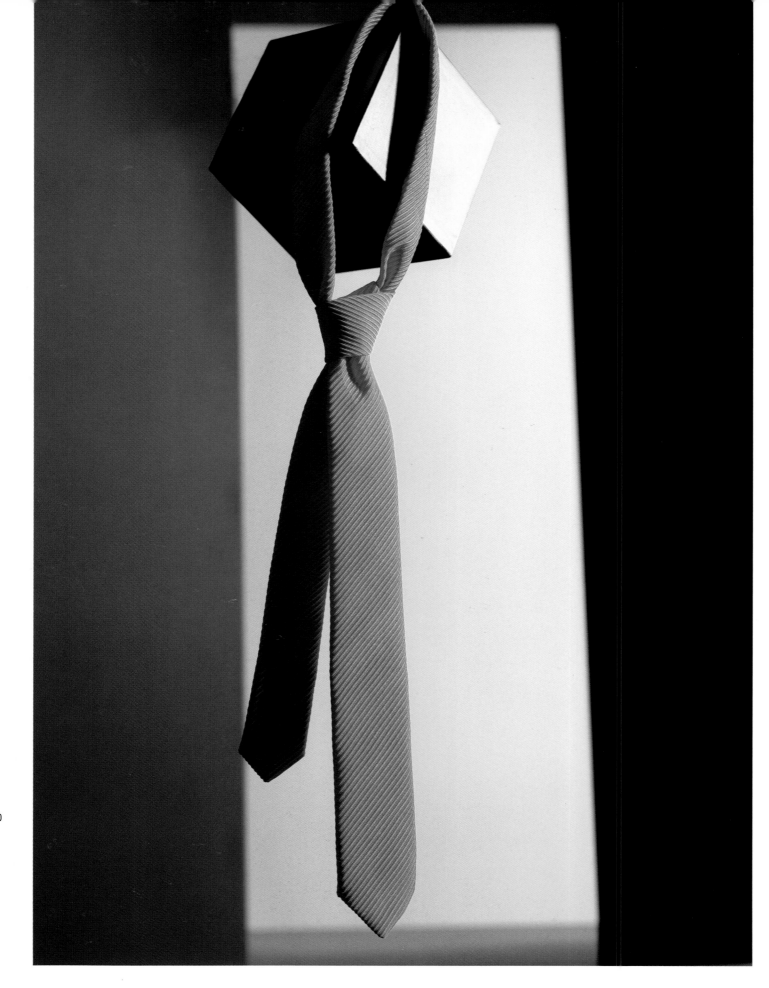

'Nothing's that complicated with what I do,' says Montgomery, 'here there's just one softbox at 45 degrees to the right. This picks out the right-hand edge of the cube and throws the back of the tie into shadow. Although it looks as though the background has also been lit separately, it's the way the card has been angled so it catches the light from the softbox. In fact, all three of the background boards are the same colour and tone. When you prefer, as I do, to work with just one light whenever possible, much of the skill comes from getting the exact angle on your reflector boards.'

practical tips

* The ties were suspended on wires which were later retouched out
* A splash of colour in a monochrome picture can have more impact than filling the frame with colour
* The way in which you angle a board can dramatically affect its tonality

 Graeme Montgomery
 L'Uomo Vogue
Editorial
6 x 6cm
150mm
Fujichrome Provia 100
1/60sec at f/16
Electronic flash

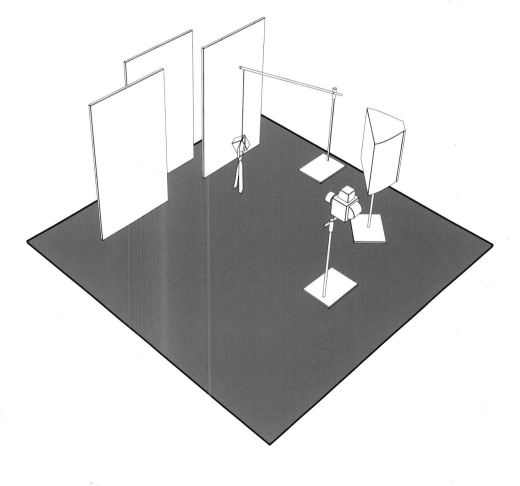

plan view

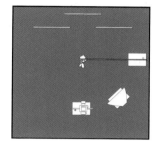

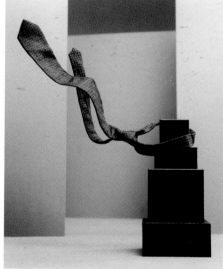

the floating tie

This exotic floating tie makes the picture look exciting, although the lighting consists of just one softbox.

The lighting for this shot was similar to that of the main picture, except the softbox was more directly overhead. It is a colour photograph, but everything in it is a shade of grey.

71

'I was looking to give this image the warm, soft feel of window light, so I used just one light to the right, with large reflector boards to bounce light back into the subject, says Montgomery. 'Although I wanted a romantic feel, I also wanted it to look modern rather than retro.'

practical tips

* Using reflectors to light your subject indirectly is a great way of creating extremely soft lighting. Shadows are much softer and illumination more even than direct lighting

Graeme Montgomery
Lulu Guinness
Brochure
5 x 4 inch
240mm
Polaroid 679
1/60sec at f/5.6
Electronic flash

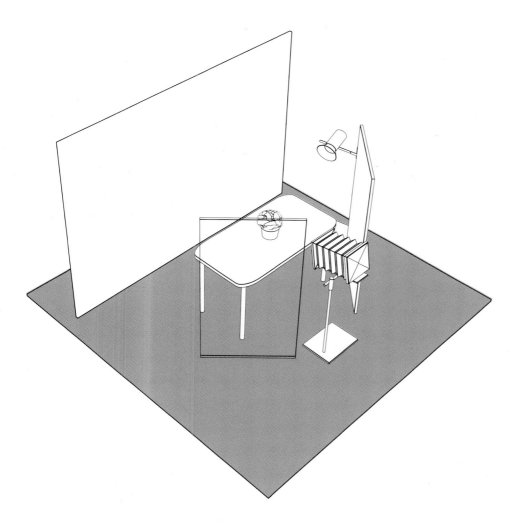

plan view

romantic lighting

A single direct light source with reflectors is ideal if you want to mimic window light.

film choice

73

The characteristics of Polaroid Type 679 film add to the soft, romantic feel.

dynamic duos

cross-lighting to reveal texture

Using cross-lighting in a small studio set reveals texture and detail.

'This is literally an old door from a hayloft,' Stone says, 'I set it up in the studio by G-clamping it to a table. The trainers are mine.'

'I wanted to reveal as much detail and texture in the door and shoes as possible, so I used strong cross-lighting. The main light, a 60cm square softbox to the left, is in the same plane as the door, and there is another head to the right, but higher up, giving a highlight on the top of the door.'

'I like to use small reflectors on stands to fill in specific areas, and here there are two, one close to ground level on the right and one a little higher.'

- Alan Stone
- Personal project
- Portfolio
- 5 x 4 inch
- 80mm
- Kodak T-Max 100
- 1/30sec at f/22
- Electronic flash

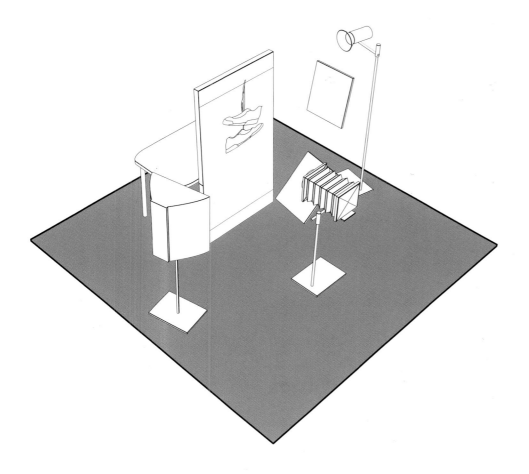

plan view

practical tip

* To make sets like this as authentic as possible, try to get hold of old, rusty nails rather than new, shiny ones

oil cans

Two softboxes used in different ways produce a soft lighting effect.

'The lighting for this shot is relatively simple,' explains Clark. 'There are two softboxes, one on each side, but they're used in slightly different ways. Only half of the one on the right is actually illuminating the set. The other half is below the table. The one on the left is fully above the table, but angled down at 45 degrees. This configuration lights the oil cans nicely, and brings out the shine. I wanted shadows – otherwise I would have elevated the cans on glass – but they needed to be soft rather than dark. As I wanted to maximise depth-of-field, I fired the flash four times to give an aperture of f/64. To soften the image further, I used a soft-focus filter under the enlarger lens when printing.'

() Anita Clark
() Competition entry
() 5 x 4 inch
() 180mm
() Ilford FP4
() 1/60sec at f/64
() Electronic flash

plan view

finding a composition

'I thought these oil cans would make a good photograph, but I didn't really know how I was going to do it. I just started to lay them out until I came up with an interesting composition. Then I had to decide what background to use. My first thought was to go for something that linked with it, such as rusty metal – but that seemed too obvious. So I decided to make my own out of modelling clay, which I pressed my fingers into to get a nice shape. I then sprayed it with car paint. That looked good, but it wasn't quite enough, so I got some metal shavings and distributed them around the backdrop.'

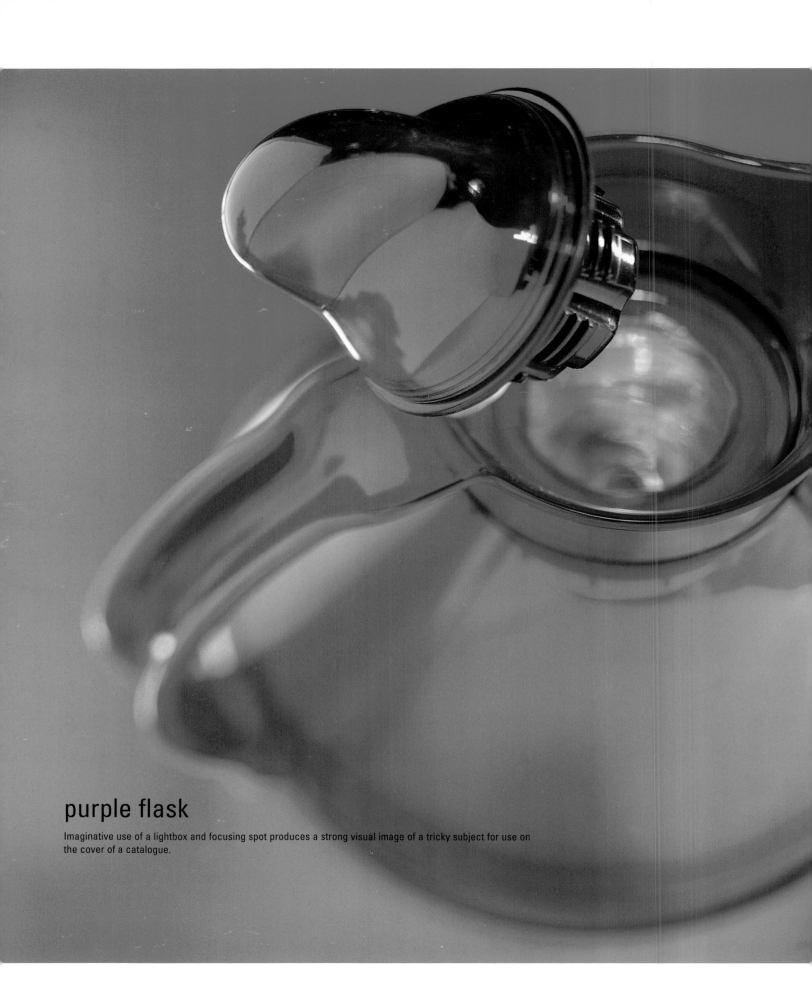

purple flask

Imaginative use of a lightbox and focusing spot produces a strong visual image of a tricky subject for use on the cover of a catalogue.

Colin Glanville knew what he wanted to do with this subject, but initially wasn't sure how to go about it. He explains, 'in the end, I used a focusing spotlight directly above the flask to get light down inside it and reflect off its silver lining, and I placed the jug itself on top of a lightbox covered with a blue gel. For convenience, I put the lightbox on the floor of the studio, rather than working on a table.'

'Having focused the light, which was a studio flash head, so that it illuminated the inside of the flask without spilling too much onto the side, I calculated the exposure to balance the flash with the continuous light source of the lightbox. I had decided to shoot at a maximum aperture, f/5.6, and so reduced the output of the flash to that level. I then measured the output of the lightbox, with a shutter speed of 1 second required at the aperture of f/5.6.'

- ⬆ Colin Glanville
- ✎ WMF
- ◉ Catalogue
- ▨ 5 x 4 inch
- ◔ 240mm
- ▣ Fujichrome Provia 1000
- ◷ 1 second at f/5.6
- ⊙ Electronic flash and lightbox

practical tips

* A lightbox can be a useful source of illumination acting very much like a softbox, especially when you want to light subjects from below. You should, however, check the colour temperature, as not all are accurately balanced to daylight
* Using gels over a lightbox quickly enables you to vary the colour of the background in 'table-top' shots such as this

plan view

limiting the plane of focus

Using camera movements and an aperture of f/5.6 limits the focus of the shot to a narrow band across the middle of the image – here from the lip of the jug to the handle. Nowhere else is focused, producing a more powerful effect than if everything had been kept sharp.

'The main light for this shot was a small softbox over to the right, about 0.6m away from the subject, throwing clear but not heavy shadows.' Cartwright continues, 'the background is some distance behind the still-life table, which prevents light spilling accidentally onto it, and is lit by a flash head in a 70 degree reflector fitted with a honeycomb on the floor. To intensify the colour of a background I often put a gel of a similar colour over the light, and here a blue gel was used to emphasise the blue paper background. The light has been positioned to burn out in the centre. Finally, the film was pushed two stops in development.'

pushing film

Traditionally, film was 'pushed', or uprated, to increase its effective speed – pushing an ISO100 film one stop would make it ISO200 and pushing it two stops would make it ISO400. But uprating film also boosts the colour and contrast, and with large formats the accompanying increase in grain size is not always an important issue.

Ian Cartwright
BASF
Trade advertisement
5 x 4 inch
210mm
Kodak Ektachrome E100S
1/125sec at f/8
Electronic flash

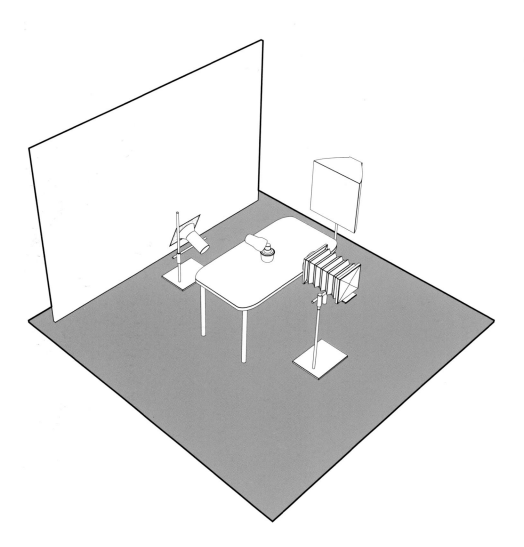

plan view

russian dolls

Just one light on the subject and one on the background help create a great sense of perspective.

securing the set

The different parts of the doll are separated inside by Blu-Tak, a small chopstick was then glued to the back of the doll to support the head.

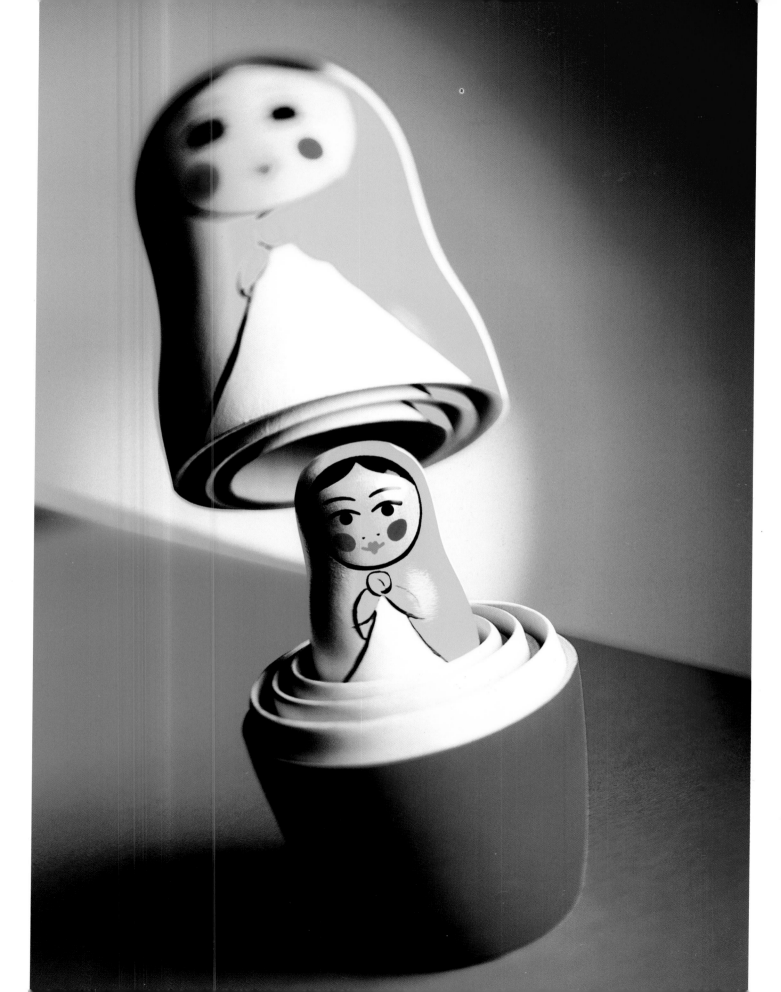

incongruous irreverence

The surreal approach of Chas Ray Krider.

Still-life photography may be a serious business for most practitioners, but that doesn't mean you can't have some fun along the way. An irreverent approach can sometimes be more effective in capturing and holding the attention of the viewer. Drawing upon the surrealist tradition, but with a stylish contemporary treatment, Chas Ray Krider likes to place objects where you wouldn't normally expect to find them – a bottle of beer in a purse or a piece of meat on the carpet. The images themselves are simple to put together and easy to light, but the effect is incongruous, disconcerting and irreverent.

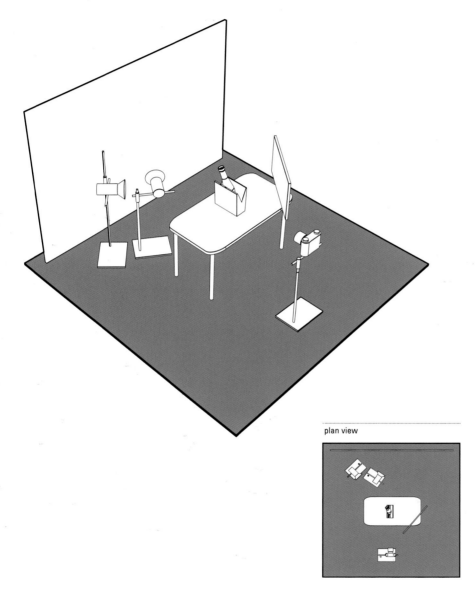

plan view

bottle and handbag

Asked by a friend with a contemporary retail clothing store to create an invitation to a party, Krider combined an item of stock – the handbag – with an object that suggests going out and having a good time – the bottle – in a new and imaginative way. The lighting is clean and fresh, with just two tungsten lamps used together with tungsten-balanced slide film. The main light, fitted with a fresnel to concentrate and control it, is at the top left and angled to rake in across the bag. A metallic reflector is placed bottom right to soften the shadows. The background is lit by a 10 inch reflector flood behind the table the set is on. The head is fitted with a blue gel, to enhance the blue of the background.

- Chas Ray Krider
- Retail clothing shop, Vagabond
- Party invitation
- 35mm
- 35mm
- Kodak tungsten 64T
- 2 seconds at f/22
- Tungsten

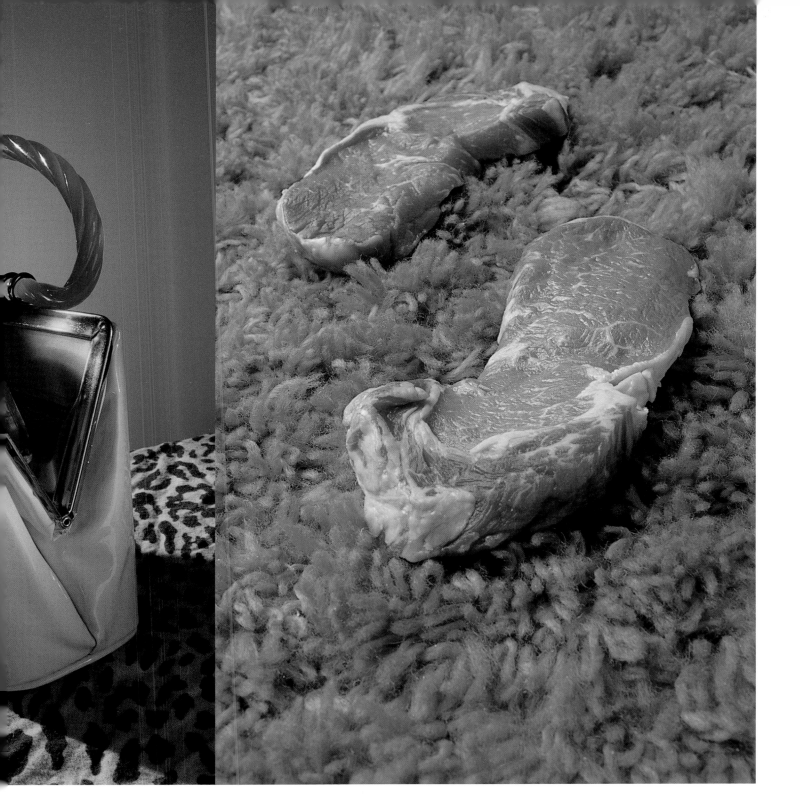

red meat on green shag pile

'I like to use colour as a seduction, and then raise a psychological question,' says Krider of this photograph. 'The red and green mean it would make a great Christmas card,' he jokes. A self-promotional shot that seems to have found its way onto the wall of many art director clients, the picture itself is commendably simple. A tungsten light at top left is angled to bring out the colour and sheen of the meat and carpet. There's a second head at the bottom right, set to one stop less and fitted with frosted material, to give fill-in without creating another set of shadows.

Chas Ray Krider
Personal project
35mm
35mm
Kodak Tungsten 64T
1 second at f/11
Tungsten

products in ice

Using a black screen to mask off the background for part of the exposure allows the effect of background light and hard lighting to be mixed.

working with ice

* You need to work as quickly as possible when shooting ice as during the whole process of setting up and checking exposure the blocks begin to melt
* Blocks of ice are extremely heavy, and need strong, fit assistants to move them around
* Place a plastic sheeting 'pool' beneath the blocks to collect the dripping water

exposure matters

'Generally I don't use a light meter, because I've learned to judge exposure, but here I integrated a range of readings which I then confirmed by shooting Polaroids.'

👤 Louisa Parry
🌐 Arena magazine
◈ Editorial
📷 5 x 4 inch
⊙ 300mm
🎞 Fuji Velvia
⏱ 1/60sec at f/64
💡 Electronic flash

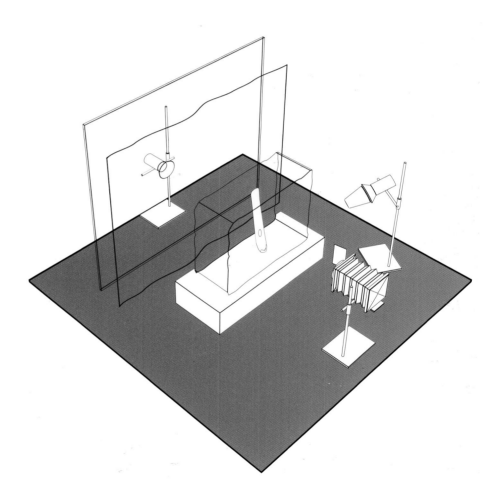

'These ski products were frozen by an ice sculptor into blocks of ice of around 2 x 3ft.' Parry goes on to explain, 'the key to the lighting of this shot is the piece of black velour behind the subject, which allows me to do two separate exposures. The first exposure is taken without velour in place, which allows the light behind to shine through the ice. This is spread and softened by a sheet of opal perspex over the head.'

'The second exposure is taken with the velour in place, using a light to the right of the camera and pointing down for illumination. This head hasn't been filtered at all – in fact there's a snoot which concentrates the light and helps bring out the sharpness and crispness of the ice. I've found that with subjects like this the harder and more directional the light, the easier it is to bring all of the detail out.'

'The material is necessary as it prevents the background being exposed when the front light goes off. To enhance the icy feeling, I fitted a light blue gel over the light that's behind and shining through the subject.'

plan view

make-up brushes

Commendably simple lighting works well for cleverly stacked subjects.

Xavier Young
Telegraph magazine
Editorial
5 x 4 inch
150mm
Fuji Velvia
1/60sec at f/16
Electronic flash

With its three layers of products, this image has all the hallmarks of having been created in Adobe Photoshop. While it would be perfectly feasible to shoot each separately and combine them in the computer, here the whole picture was created in-camera without recourse even to multiple exposure.

The cotton buds and the sponges are sitting directly on a sheet of perspex, above which there are two layers of glass, stacked up at equal distances. On the first one are the eyebrow tweezers and some of the bigger brushes, and on the second most of the smaller brushes. Not surprisingly, it took the photographer some time to get all of the elements positioned so they looked right and worked well together.

The lighting just uses two flash heads. Beneath the perspex is a softbox which provides trans-illumination and the white background. A striplight on the left and a long, thin strip of white card on the right-hand side creates fill-in. The most important thing in creating this photograph was to make sure everything was level and upright – including the camera – or the shot would simply not have worked. It was also essential to cover the front of the camera with black velvet, to avoid it reflecting in the glass and other shiny parts of the products.

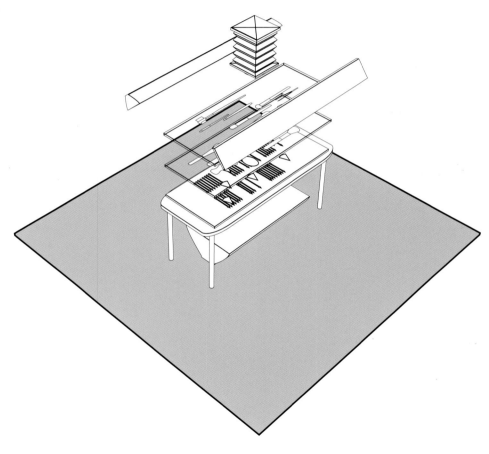

lighting accessories

Xavier Young describes his most important lighting accessories as being: 'black, white and silver card and a few little mirrors. White will often bounce back more light than silver, silver is more directional and has to be angled accurately – the one I use is slightly matt. The cardboard bases that are used for cakes are excellent since they have a pattern printed on them that breaks up the light. I don't use silver foil because it's so hard to get it to lie perfectly flat, and you end up with hard highlights and hot spots.'

plan view

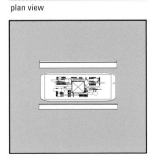

fireman's helmet

Precise control is gained by tightly directing light, rather than letting it wash all over the subject.

'As well as photographing this fireman's helmet in a standard pack-shot way to show it clearly, we also wanted a more interesting image with lots of impact,' says Young. 'I spent ages peering at different parts to find which section was the most interesting. Because the helmet is largely transparent, I decided to light it mainly from below – so it's resting on its side on a sheet of perspex, raised up on a roll of gaffer tape to stabilise it.'

'On the perspex, beneath the helmet, are two sheets of material: a coloured gel and sheet of special tracing paper on top that prevents any uneven reflections. The light coming from below is on a floor stand and has a honeycomb fitted to make it hard and contrasty. This makes the reflections within the helmet more graduated, and causes the light to fade into the corners of the frame.'

'The second light has a yellow standard gel and is placed 2m away from the subject, at 90 degrees to the camera. The light is fitted with a honeycomb to focus the beam and two sheets of black card were placed two inches apart close to the subject to focus the beam further. The result is a controlled shaft of yellow light that avoids killing the dark reflections.'

- Xavier Young
- Random Technologies
- Brochure
- 5 x 4 inch
- 150mm
- Fuji Velvia
- 1/60sec at f/22
- Electronic flash

plan view

using formica

Young finds that 'Formica is ideal for reflectors because it's stiff enough to stay where placed but can still be curved to fit, paper just goes floppy. I tend to buy 10 x 4ft sheets of Formica which I then cut to size as needed.'

This picture, which was also used in the brochure, was actually very difficult to shoot, because it's so reflective. The main light is a softbox directly to the right of the camera and angled over the helmet. A sheet of Formica is on the left leaning from the floor to the top of the lightbox.

diamond chairs

Here, two lights, one for the subject and one for the background, bring out the restrained detail in these attractive chairs.

Two chairs were used, with one laid on top of the other, to make a more interesting composition. To bring out the texture and detail, Hemsley used one square head to the left of the camera, about 2m from the subject, fitted with a honeycomb grid. There's a 2 x 1.5m reflector board to the right of the chair, to soften the shadows slightly. The background is a roll of white paper which was coloured by means of an orange gel over a spotlight. This was positioned to the left of the camera.

🚶 Mike Hemsley
🌀 J. Tanous Furniture
◉ Promotional catalogue
📷 4 x 5 inch
◎ 140mm
▶ Kodak EPP
🕐 1/60sec at f/16
💡 Elinchrom studio pack

plan view

practical tips

* Cross-lighting, with the main light positioned to one side, is a great way of bringing out detail and texture
* Using a white roll and fitting gels over a background light saves the need for different coloured backgrounds

Mike took several different shots of the chairs, including this one using a wide-angle lens in close for a more dramatic perspective.

95

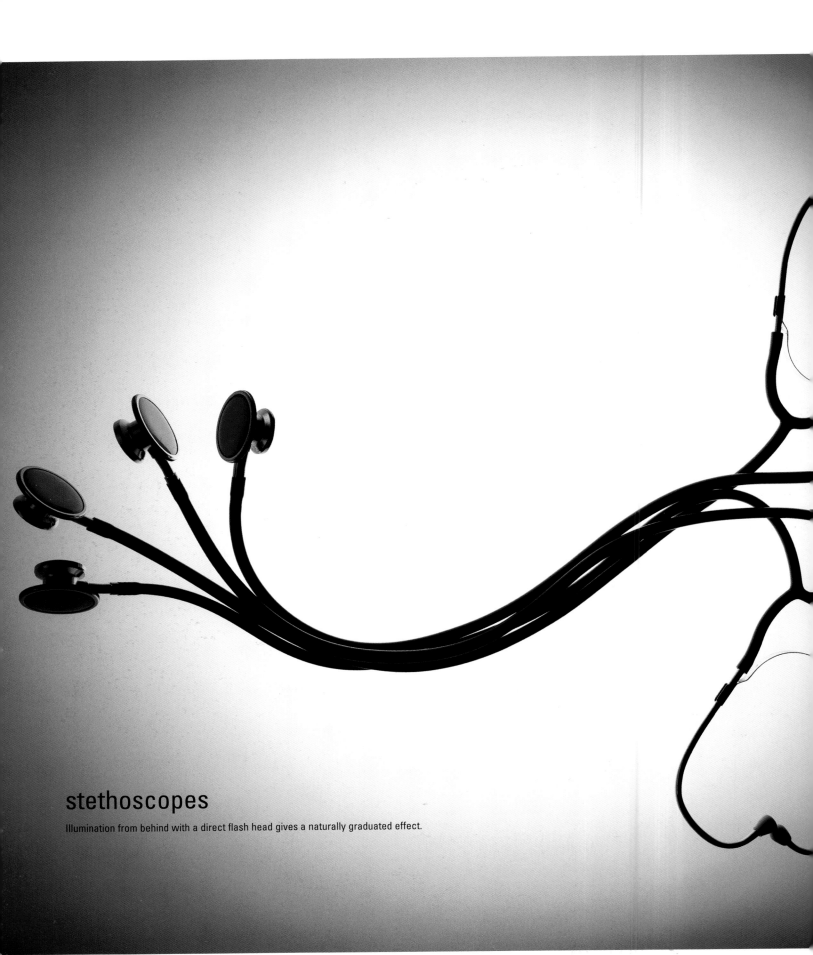

stethoscopes

Illumination from behind with a direct flash head gives a naturally graduated effect.

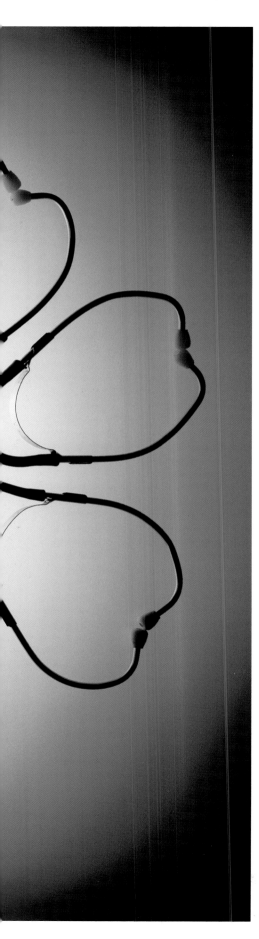

While some still-life subjects have shapes and forms that seem to make photography simple, other subjects are more tricky. This is particularly true of long, thin objects which can end up looking insubstantial and unsatisfactory. These stethoscopes are a case in point. Short of putting them round the neck of a doctor or nurse, there's nothing much to photograph. However, by bringing four together, laying them out in an interesting and elegant way, and lighting them to give a semi-silhouette effect, an attractive composition has been created. As with most 'floating' pictures, the stethoscopes are lying on a sheet of glass, a sheet of pink plastic has been placed on top to provide the colouring.

A raw head with a perspex cover placed below the glass provides most of the illumination. The light is close to the glass so the centre of the image burns out and the colour graduates naturally in from the edges. The stethoscopes are on the glass rather than on the perspex-covered light itself because then you'd have light showing around the edges, and there's always a risk of flare. To balance the exposure, and reveal just a little of the detail, there's a softbox angled at 45 degrees and fired through a sheet of opal perspex.

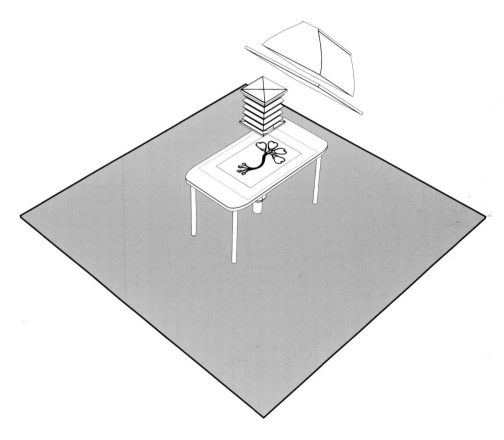

plan view

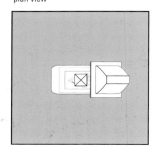

- Louisa Parry
- Personal project
- Portfolio
- 5 x 4 inch
- 210mm
- Fuji Velvia
- 1/125sec at f/64
- Electronic flash

mussels

Placing all of the illumination behind a semi-translucent subject helps reveal texture and colour.

'Although this looks at first sight like a reflection, there are in fact two separate mussels, which are on a sheet of glass with the light behind. The mussels are stuck to the glass to prevent them moving.'

Parry explains further, 'I wanted the mussels to glow and the markings on their shells to be seen, so I used a spot head from underneath to direct a shaft of light onto them. I was careful not to let the light hit any other part of the glass otherwise any dust or marks could show up on the film. I wanted just a plain-coloured background, so a large, even light was needed, I used a large softbox fitted with a straw gel. The mussels were also influenced slightly by the background light, in respect of colour, and to a certain extent that was what I was after – that the mussels be a similar colour to the background.'

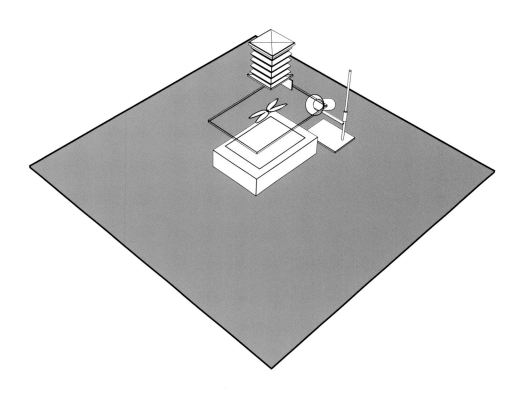

plan view

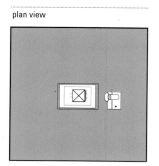

Louisa Parry
Personal project
Portfolio
Editorial
5 x 4 inch
210mm
Fuji Velvia
1/60sec at f/64
Electronic flash

'This shot was done in two parts,' explains Parry. 'The first exposure captures the basket resting on the glass. It is lit by a softbox angled at 45 degrees, from near the camera. Black velour is placed around the basket, to prevent the light hitting the glass and reflecting back. The black material is then removed very carefully, so the basket doesn't move, and a second exposure is made for the lighting from below, which comes from a round flash head with a square disk through an opal perspex screen.

'The 'shaking' effect is achieved by means of a filter which is screwed onto the front of the lens during the second background exposure. Overall, I wanted the light to be a soft as possible, because the subject is so shiny and silvery, and any little bit of light risks being reflected back.'

- Louisa Parry
- Personal project
- Portfolio
- 10 x 8 inch
- 210mm
- Fuji Velvia
- 1/60sec at f/64
- Two heads

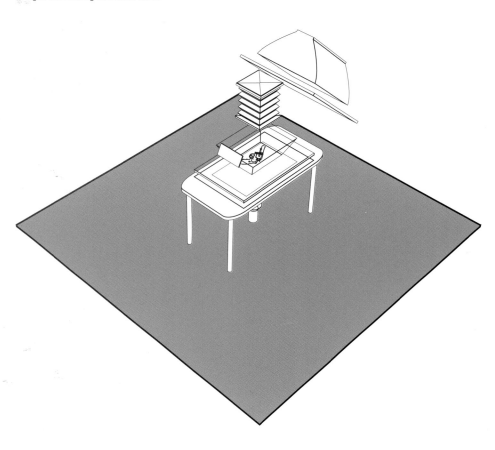

100

gun in a shopping basket

Soft lighting prevents highly reflective subjects from appearing distorted by their reflections.

plan view

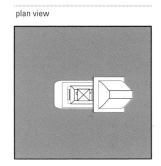

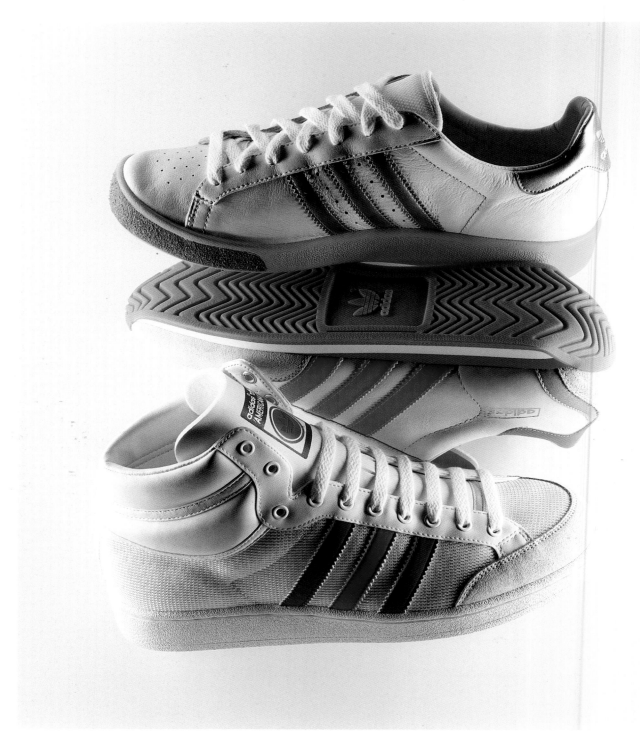

trainers

Cross-lighting and a plain background give a clean, modern feel to this editorial image.

Simon McCann describes, 'this is a fairly straightforward cross-lighting shot, with linear striplights either side of the subject, as close as possible without actually being seen by the lens. To soften any shadows further, there are two pieces of white A3 card either side of the camera acting as reflectors.'

'The background is also white card, and the trainers are raised up a couple of inches to avoid creating shadows and to look as if they are floating. The camera is directly above the set, and the trainers side-by-side, but the effect is as if they are stacked up on top of each other.'

Ⓐ Simon McCann
Ⓢ The Face magazine
Ⓔ Editorial
Ⓕ 6 x 6cm
Ⓛ 120mm
Ⓕ Fuji Velvia
Ⓣ 1/2sec at f/11
Ⓛ Strip lighting

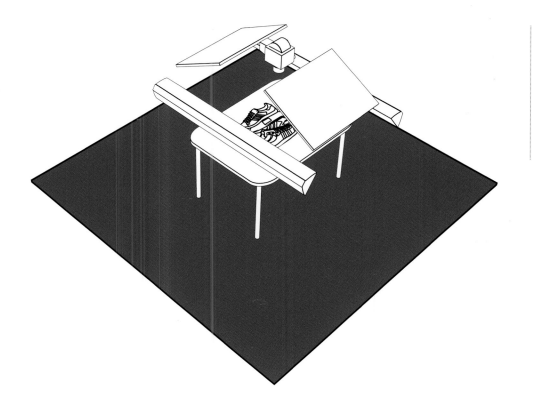

plan view

hard case

Using two continuous light sources in close gives a dramatic, sculptured look to a solid object.

'This case is such a huge, solid object, I knew I would need to do something to break it up a bit', comments McCann. 'First of all using a dramatic angle makes it look like a piece of architecture. Then by raking the light so just parts of it are picked out, some parts become invisible.'

'I used linear striplights, which I've been using for the last four years, because they are very, very flexible. They're a daylight-balanced ambient light source featuring a 4ft single tube which comes in a housing with a reflector and doors you can use to baffle the light. There's one striplight on the left which is really close, positioned to catch the edge of the case, but not all of it; this gives you that hard, blown-out front edge. The other striplight is about 2m behind and 1m to the right, just out of shot, and it rakes along the side of the case. Finally, there was a piece of A1 card which was placed just to the right of the camera to give the reflection on the corner. The case itself is resting on black velvet, and there's more black velvet behind.'

👤	Simon McCann
◈	Test shot
📷	6 x 7cm
◉	110mm
▣	Kodak Pro Gold 160
⏱	30 seconds at f/22
💡	Striplighting

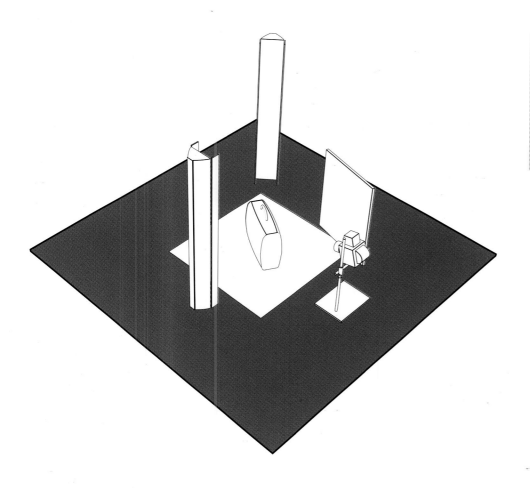

plan view

Working with striplights

One disadvantage of working with striplights is that because they have a fixed output you can't turn them up or down like flash – so when you want to make the light stronger or weaker, you have to move them physically back and forth. Exposures can also be long, 30 seconds is not unusual. On the plus side, however, the fact that they're a continuous light source means that what you see is what you get. They're not appropriate for everything, but you can do things with them you can't do with flash. You can use them very close without getting flare, and they're relatively soft compared to flash.

'When I saw this can I knew I wanted to do something with it. I just loved the styling and the colour.' McCann continues, 'it's basically a silver can but with a green strip. I wanted to work very simply with it, so I put a single dent in the side and put it on an off-white backdrop with no texture. It's raised up a couple of inches to avoid any shadows. The can is basically crosslit with a striplight either side, and there's an opaline screen in front to soften the light further. Above each light there's a strip of blue paper which gives the cast on the image.'

- Simon McCann
- Test shot
- 6 x 7cm
- 110mm + extension tube
- Kodak Pro Gold 160
- 30 seconds at f/22
- Strip lighting

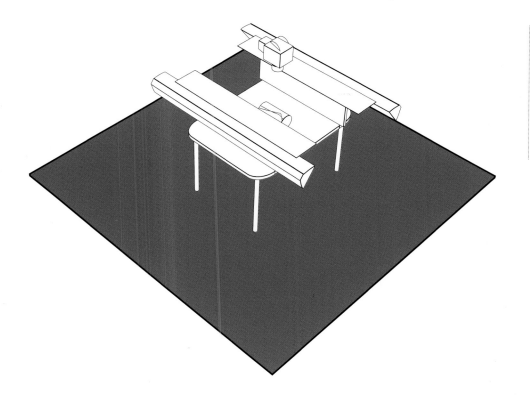

plan view

Japanese can

Lighting with striplights through an opaline screen produces extremely soft illumination.

'This was lit with two softboxes, one illuminating the vase and flower and one lighting the background,' Bleach describes. 'It's a double exposure, with the background masked off with black velvet during the exposure of the subject, to make sure that no white light fell onto it. I wanted the right-hand side of the vase to go black, so I placed the softbox at 90 degrees and didn't use any reflectors on the opposite side. The background is just a sheet of hardboard painted blue, but to make the colour even richer the light illuminating it has a blue gel over it. As a finishing touch, the petals were sprayed with water, to echo the texture in the vase and the background.'

- 👤 Bernard Bleach
- Personal project
- Portfolio
- 5 x 4 inch
- 210mm
- Fuji Velvia
- 1/60sec at f/32
- Electronic flash

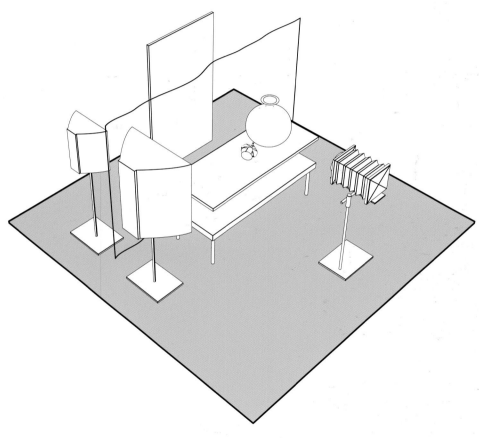

blue vase and daffodil

Two softboxes and a double exposure create a richly colourful composition.

plan view

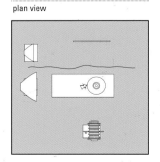

lighting with slide projectors

Slide projectors can be versatile lighting tools.

'I was looking for a graphic and unusual way of illustrating an article about the different kinds of bread you can get from around the world, and came up with the idea of incorporating some of the names in the lighting.' says Harwood.

'For this I used two slide projectors, both positioned to the left of the camera. The words were created on an Apple Macintosh computer and printed out on acetate, which was then cut down to size and fitted into standard 35mm slide mounts. The bread was then laid out attractively on a sheet of white card and the projectors positioned in terms of distance and angle to give the most pleasing effect. The set was also illuminated by daylight coming in from a window behind, which provided an overall 'fill' but without significantly reducing the contrast of the text. The great thing about with working with a continuous light source is that you can see exactly what you're getting.'

- Paul Harwood
- Editorial
- 6 x 6cm
- 80mm
- Fuji Velvia
- Not known
- Two slide projectors

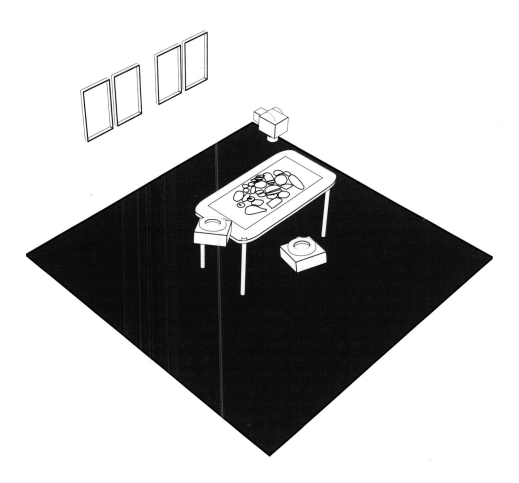

plan view

This photograph repeats the technique in a different context. Here though, there's just one projector to the left, and sheet music has appropriately been employed as a backdrop.

using slide projectors

Slide projectors vary in the colour of their light output, largely according to the kind of lamp used and its age. Before using them for a commission it's a good idea to carry out a series of tests to check the colour balance.

111

'This picture was taken using a combination of continuous lighting and studio flash.' Cartwright continues, 'the lipstick is resting on a daylight-balanced lightbox on which has been placed two coloured gels; there's a strip of blue and the whole of the rest behind the lipstick is green. The gels are reflecting into the metal sides of the lipstick, and the strip of white is where the gels run out. The different tones come from the overlapping out-of-focus colours and the degree of exposure. To the left of the camera, throwing the highlight onto the lipstick, is a flash head with a 70 inch reflector. I used a 90mm wide-angle lens in close to create a dramatic perspective and the depth of field is limited by shooting at f/5.6. Getting the flash output low enough at such large apertures is tricky, so the head was around 2m away and we fitted a honeycomb to cut it down.' Cartwright also pushed the film two stops in development.

- Ian Cartwright
- BASF
- Trade advertisement
- 5 x 4 inch
- 90mm
- Kodak Ektachrome E100S
- 1/2sec at f/5.6
- One flash head and a lightbox

using a lightbox as a light source

Daylight-balanced light boxes can make an excellent light source, especially when subjects need to be lit from underneath. Check, however, that the lighting is even, a sheet of opal perspex can be laid over the top to soften the illumination further.

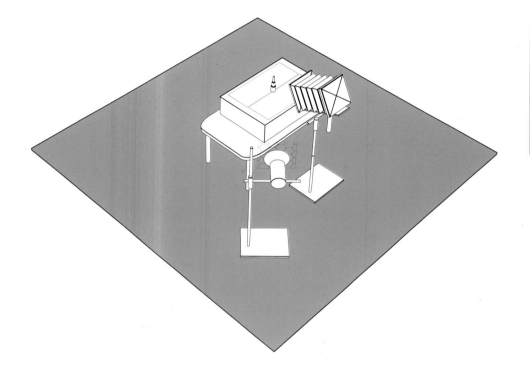

plan view

lipstick

113

Sometimes the simplest solution is to use ready-made lighting options such as a lightbox.

'My approach to lighting involves using one or two main lights with a number of mirrors to bounce lights back into the subject,' says Warren. 'I sometimes also place objects in front of the lights to create shadows. The mirrors are tiles which I buy from a DIY store and cut to the size and shape required. I hold them in place with Blu-Tak.'

'This shot is mainly about colour, texture and contrast, and the lighting is designed to support that. The lights are low to reveal the texture, and to define the rim of the plate and fork while the mirrors and boxes create areas of highlight and shadow. There are only two colours in the picture, and the composition itself is simple and clinical. I deliberately positioned the chilli using the rule-of-thirds.'

(人) Neil Warren
(⊖) Personal project
(◉) Various
(▣) 5 x 4 inch
(◍) 210mm
(▷) Fujichrome
(⏲) 1/30sec at f/16
(◉) Electronic flash

plan view

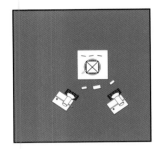

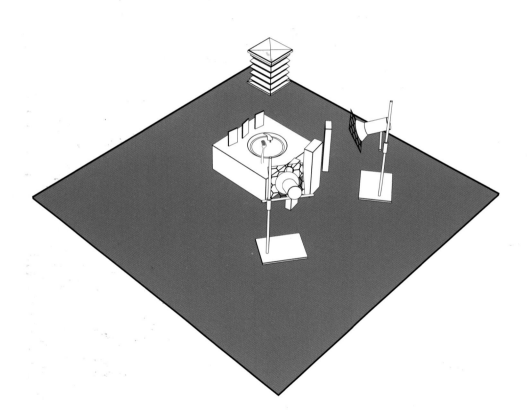

red chilli

Using mirrors to bounce back the lighting from electronic flash heads gives precise control over lighting small sets.

creating texture

Warren sprayed the plate and the fork with adhesive spray glue and sprinkled sand over them, over which he then used spray car paint.

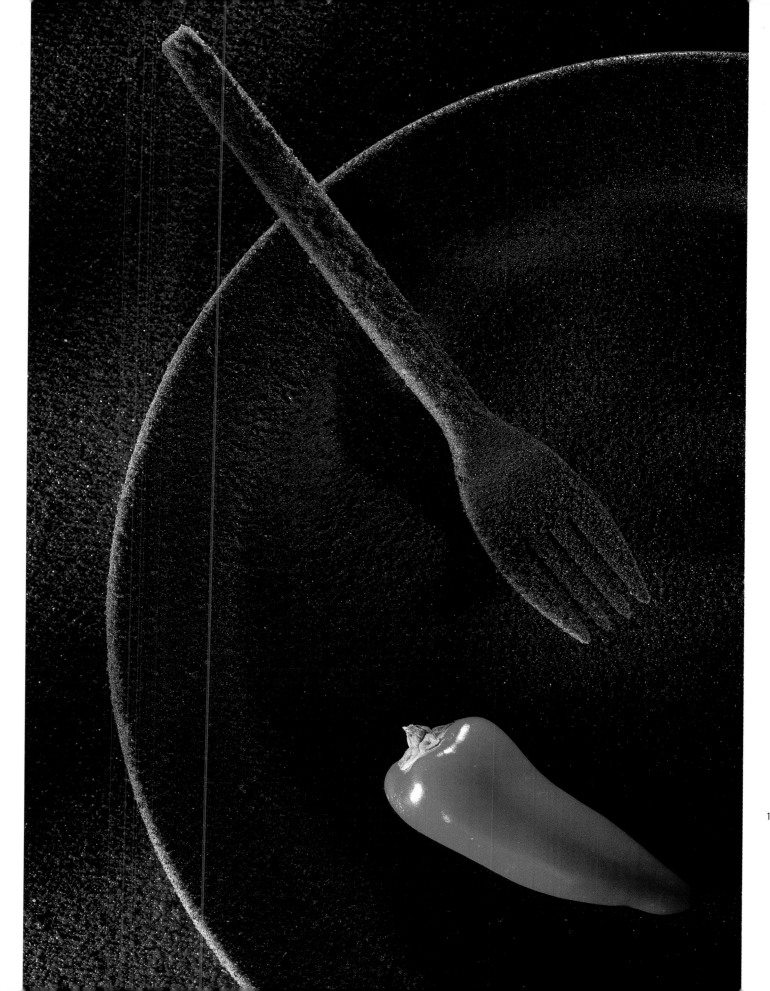

Louisa Parry wanted soft, almost shadowless lighting for this shot, saying, 'as well as using a softbox I also placed a sheet of perspex between the light and the subject. The softbox was at 45 degrees and at the top of the shot, so the light was graded from top to bottom. I like to use a small aperture to get everything in focus, so I use powerful strobe lighting, even so, I had to fire the flash-head twice to get f/64.'

ⓧ Louisa Parry
ⓧ Personal project
ⓧ Portfolio
ⓧ 10 x 8 inch
ⓧ 300mm
ⓧ Fuji Velvia
ⓧ 1/60sec at f/64
ⓧ Electronic flash

plan view

how the set-up was achieved

Parry describes: 'the idea for this picture was that somebody had left a match on a book and it had burnt a hole into it. I began by allowing several matches to burn back on a piece of metal until I got one that looked the right shape. I then found a sheet of art paper, drew round the match in the same shape, cut a hole smaller than the match and burnt it with a lighter. It took a few goes to get it right. I then did the same with other sheets, decreasing the size of the hole each time, to look as if the match had been dying out.'

on composition

'I originally tried composing the image with the match in the middle, but it just didn't seem to make sense. So I experimented with other arrangements and it just looked right when I placed it off-center.'

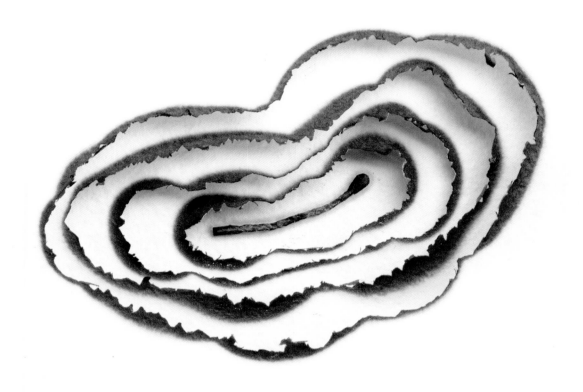

burnt match

Introducing a perspex screen between the flash-head and the subject softens the illumination further.

Black objects can be notoriously difficult to light. The shape and volume need defining, which means introducing lighter areas, but the sense of blackness should not be lost. Here Montgomery has got it just right, with an excellent balance between the areas of shadow and the highlights – with a full tonal range in-between. Surprisingly perhaps, all this was achieved with just one softbox directly above the camera and angled down at 45 degrees. The highlights beneath were generated by the white card that the bangles and feather were resting on. The background was also white card which was lit from behind to give a middle grey. The subtle colouring was retouched in later.

- Graeme Montgomery
- Vogue Gioiello magazine
- Editorial
- 6 x 6cm
- 150mm
- Fujichrome Provia 100
- 1/60sec at f/16
- Electronic flash

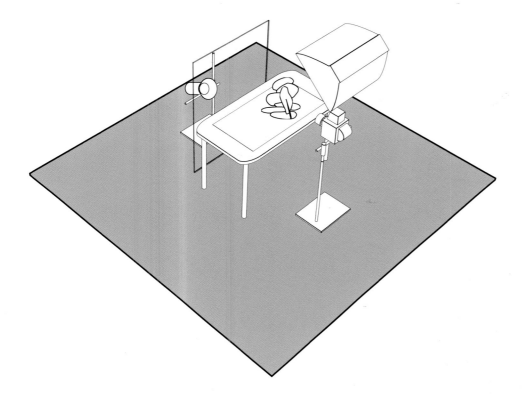

plan view

feather with bangles

With just one softbox strategically placed, it's possible to bring dark subjects to life.

practical tip

119

* Adding a contrasting element can enhance the essence of the shot. Here the softness, delicacy and lightness of the feather helps emphasise the hardness, solidity and darkness of the bangles

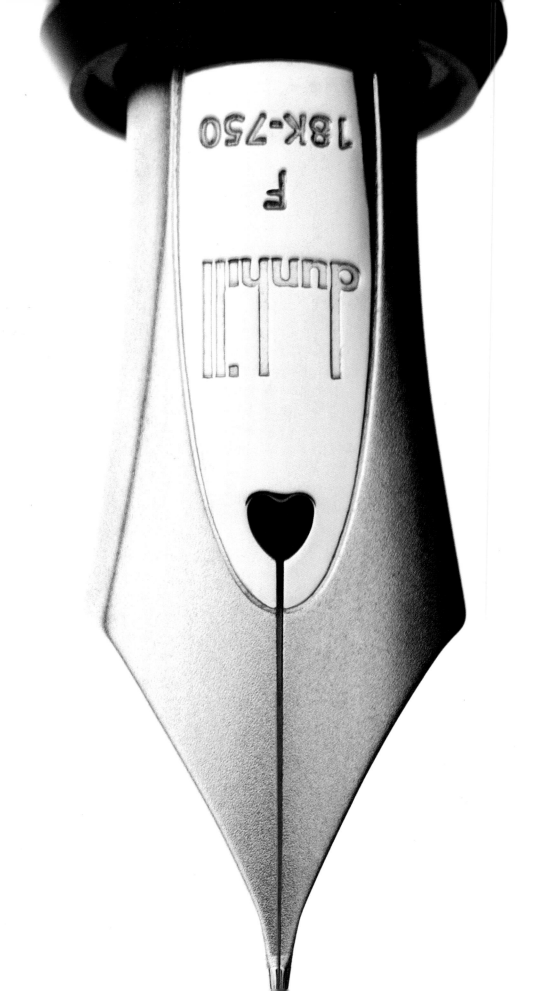

The resolving power and sharpness of a 5 x 4 camera fitted with a close-up ring makes it possible to produce stunning close-up still lifes like this. Rather than photograph the whole of the pen, which so easily could have lacked impact, the photographer cropped in tight on the most interesting part – which also included the client's name. To reveal the logo, the lighting had to be perfectly positioned and angled, and the exposure had to be just right. The top of the nib is lit by one softbox from above, and angled in at 45 degrees. To produce the clean, white backdrop, the nib was on thick perspex lit from below by one flash head.

Graeme Montgomery
Vogue Gioiello magazine
Editorial
5 x 4 inch
150mm + close-up ring
Fujichrome Provia 100
1/60sec at f/16
Electronic flash

plan view

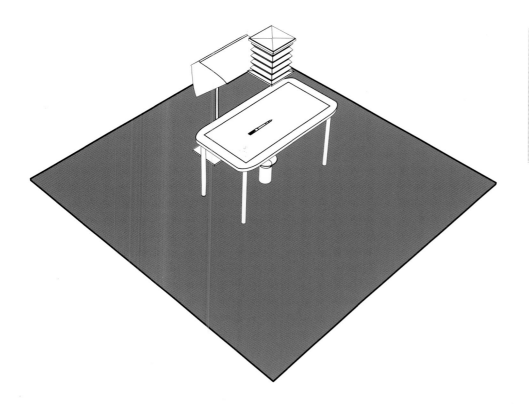

nib

With illumination from the back to clean up the whites, only one softbox is required for illuminating the subject.

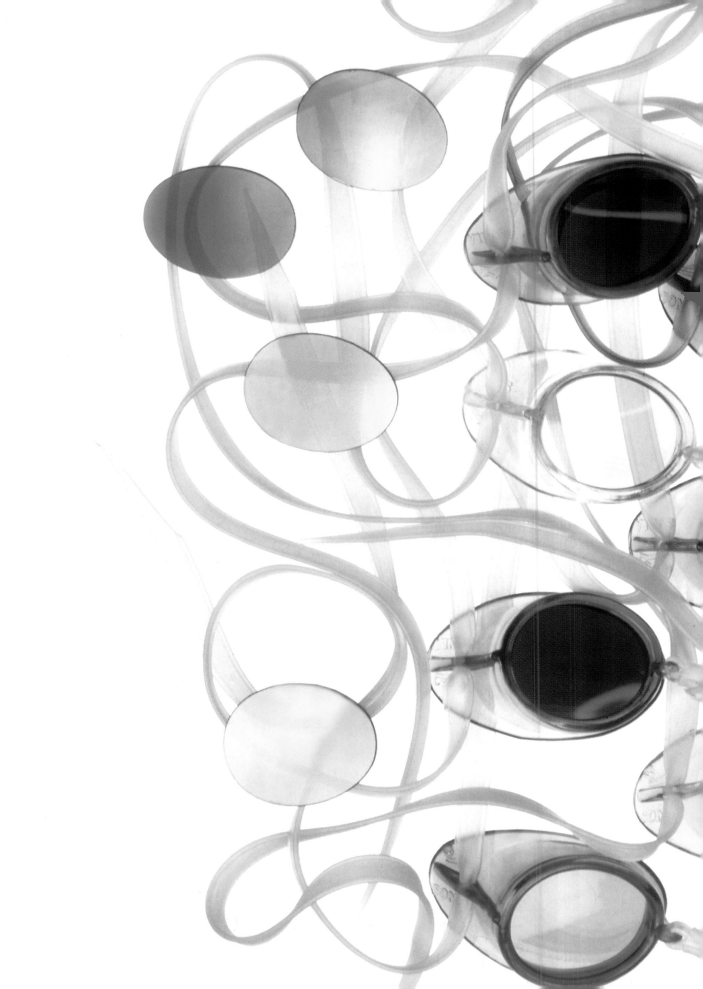

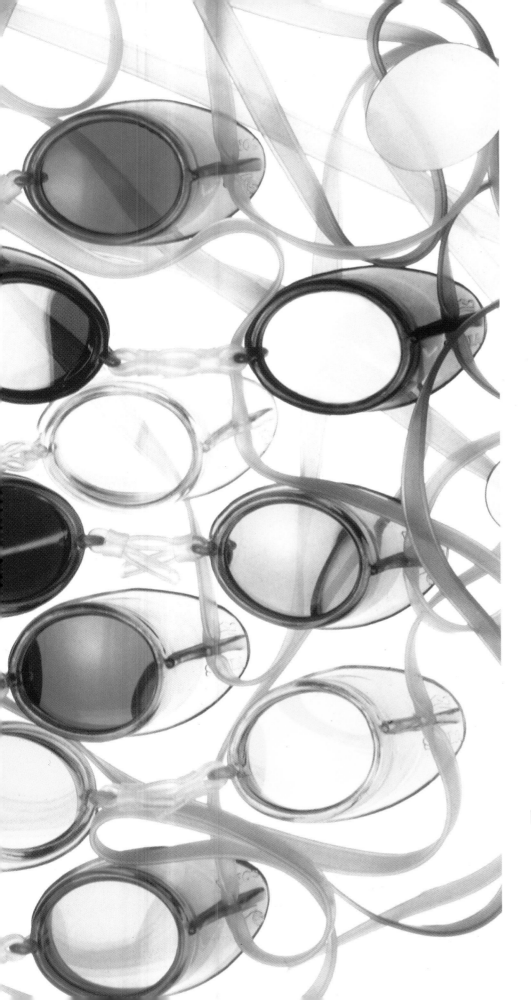

multiple lighting

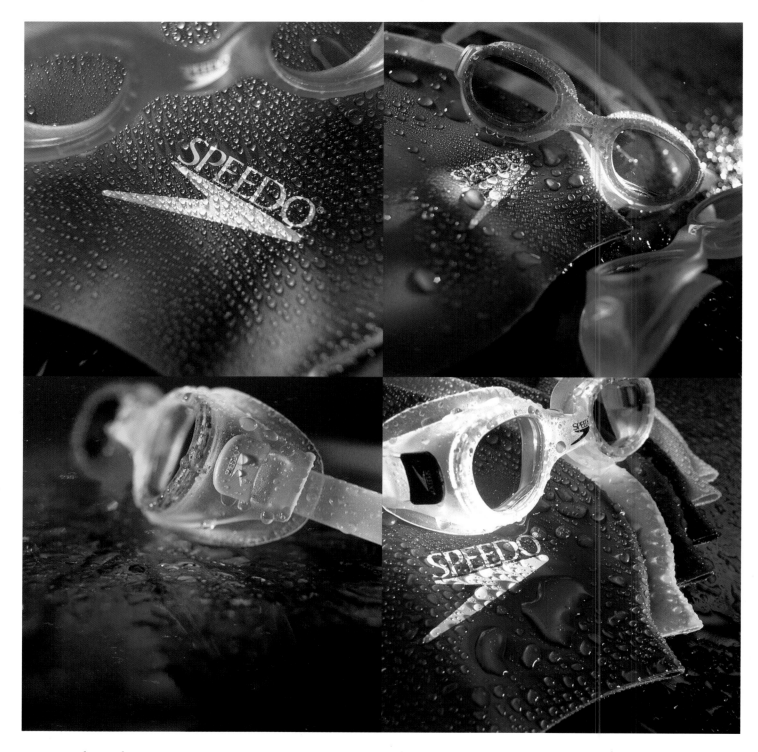

speedo shoot

Oblique lighting combined with water droplets helps create interesting textures, bringing these ordinary objects to life.

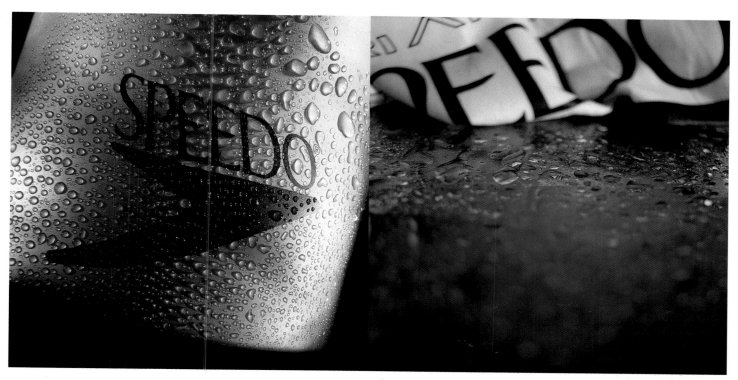

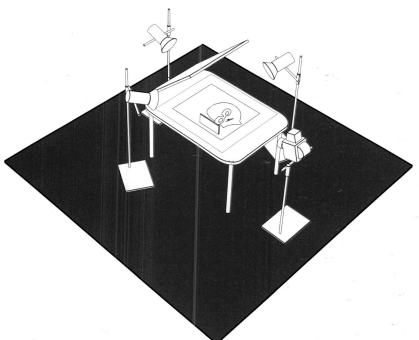

plan view

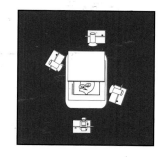

Peter Dawes describes the shoot; 'although these products have appeal to the public because of the Speedo name, some of the objects are not especially attractive and I had an open brief to do something interesting with them. When you put too much light on products like these they just go flat, so I deliberately kept it low key. The main light is a spot from the right, designed to give a hard edge and plenty of contrast. There's a second light coming from the back – a direct flash head fired through a sheet of Kodatrace diffusion material angled at 30 degrees. It's positioned close to the set because if it's too far away the light is not localised and starts to spread all over the place. This light is fitted with a blue gel to colour the background and help create the nice texture in the water droplets. I didn't need to add anything to the water – because the hats are made of silicon, it pools naturally. Finally, there's a kick light coming in from the top left, quite low, and there's also a metal reflector providing highlights from the left. All the products are sitting on black perspex, and I used a wide-angle lens fitted with a close-up ring for a dramatic perspective.'

- Peter Dawes
- Speedo
- Brochure
- 6 x 6cm
- 50mm + close-up ring
- Fuji Velvia
- 1/125sec at f/16
- Electronic flash

125

'This was a tricky industrial subject to light,' Connor Tilson explains, 'and my aim was to exploit pattern, texture and form. The product is actually polished chrome, but we wanted it to look gold, and so used various gels to create that effect.'

'I wanted to create 'banners' of light, so I masked down four softboxes to produce upright strips of light. These were positioned at the four corners. A blue backlight gives the feeling of night-time. To get the aperture of f/32 the flash heads were fired manually. The shot was set up in a totally black room, and because of the gels, each of the softboxes had different exposures; some received just one, others two and some five flashes. Having completed the flash exposures, the crucial thing was then to get the image projected onto the background and exposed correctly. The timing for this was around two minutes.'

'The reflection of the hose couplings comes from placing them on perspex wrapped in cling-film.'

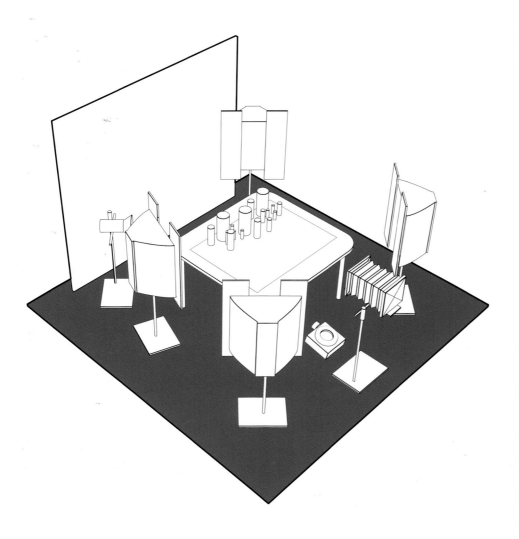

126

hydraulic hose couplings

Intricate lighting using five lights and back-projection produces a surreal image.

plan view

practical tips

* You can create a striplight effect by masking off parts of a large softbox with tape and black card
* Wrapping cling-film over reflective perspex gives a ripple effect

Connor Tilson
Flexequip
Catalogue/exhibition/corporate literature
5 x 4 inch
240mm lens
Fujichrome Provia 100
Various exposures at f/32
Electronic flash and slide projector

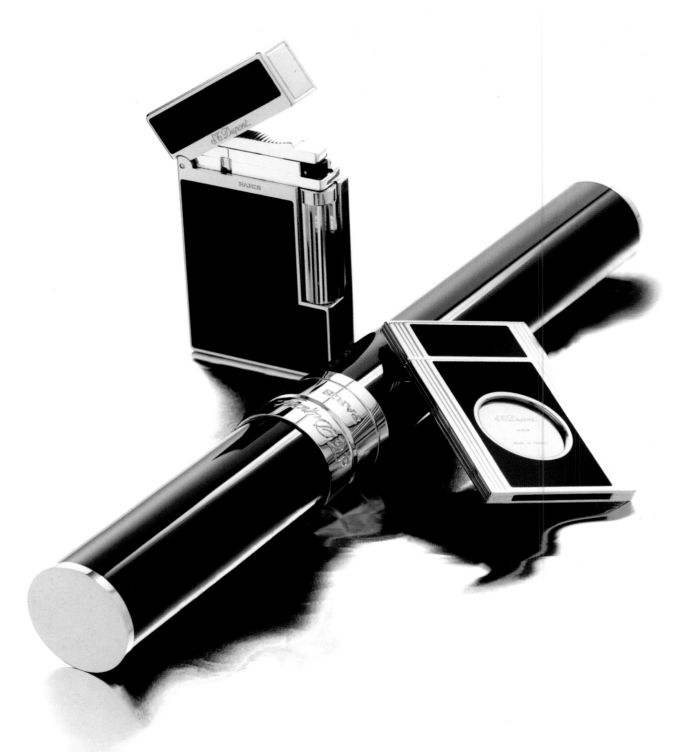

reflected glory

Two softboxes used in different ways produce a soft lighting effect.

'This was for an advertising campaign whose copy line was "A reflection on perfection",' says Montgomery. 'I experimented with various reflective materials before settling on aluminium foil. What I like is that by rippling it you can get an impressionistic effect – like water rather than glass. I used three lights, which for me is a lot, although it's still relatively simple. The lighter, cigar case and cutter are lit directly by two softboxes, one on each side of the camera and both angled down at 45 degrees. There's also an 8 x 4ft white board 3m behind with a light aimed at it, effectively turning it into a huge softbox that flooded the set with light from the rear.'

- Graeme Montgomery
- Dupont
- Advertising campaign
- 5 x 4 inch
- 150mm
- Fujichrome Provia 100
- 1/60sec at f/16
- Electronic flash

plan view

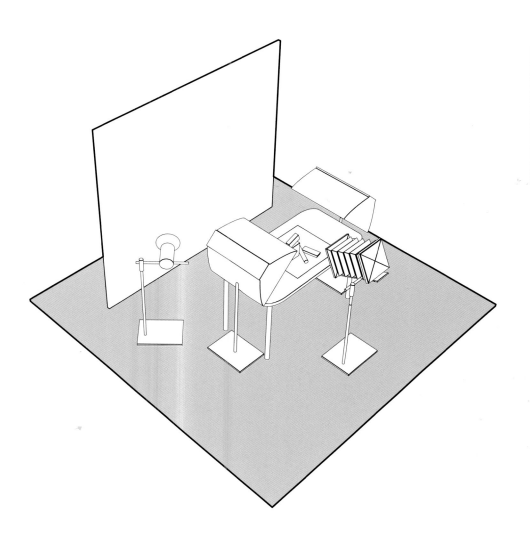

practical tip

* One simple way of generating soft lighting that's more like daylight is to bounce the light from a large white surface. Boards offer the greatest flexibility, as you can move them around, but walls and ceilings can also be used to good effect

mousetrap

When you use a large amount of lighting, the light needs to be controlled very carefully.

Ⓝ Neil Warren
Ⓢ Personal project
Ⓟ Portfolio
Ⓒ 5 x 4 inch
Ⓛ 210mm
Ⓕ Kodak Ektachrome
Ⓣ 1 second at f/22 (multiple flash)
Ⓘ Broncolor flash and tungsten
Ⓢ Set built in studio using 'flats' and board

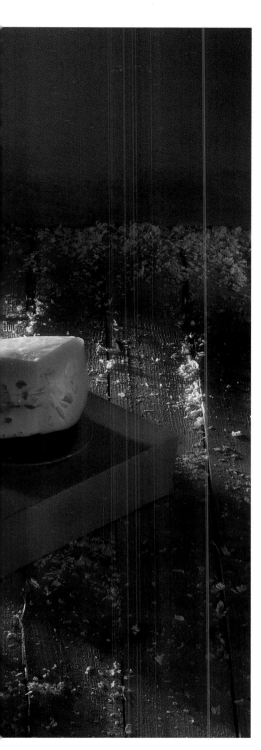

'The whole idea of this shot was to play around with scale,' says Warren, who had the mousetrap made to order by a model-maker to his specification. 'It's hard to tell from the photograph, but in fact it's 1m long – and the piece of cheese on it cost over £50! I built the set to have an old barn feel, and lit it accordingly with a mixture of flash and tungsten.'

'There are also a number of mirror tiles around the set, positioned as close as possible without appearing in the picture, to selectively light small areas of the scene, in particular the cheese.'

'The shot was all built up in the studio. I do a lot of room set photography, and so had most of what I needed, such as the door and the 'flats', already to hand. To create the 'floor', I bought a fencing panel from a DIY shop for £10, and then sprinkled some sawdust and sand to make it look convincing.'

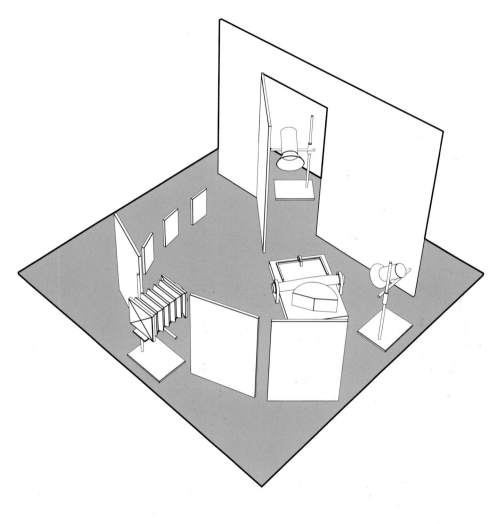

practical tips

* Mixing tungsten lighting with flash gives an attractive effect where part of the subject is orange and part neutral
* The diagonal arrangement creates more visual impact than a 'head-on' composition would have done
* Mirror tiles from hardware shops are ideal for controlled lighting effects
* Paying attention to small details makes the whole shot look far more believable

plan view

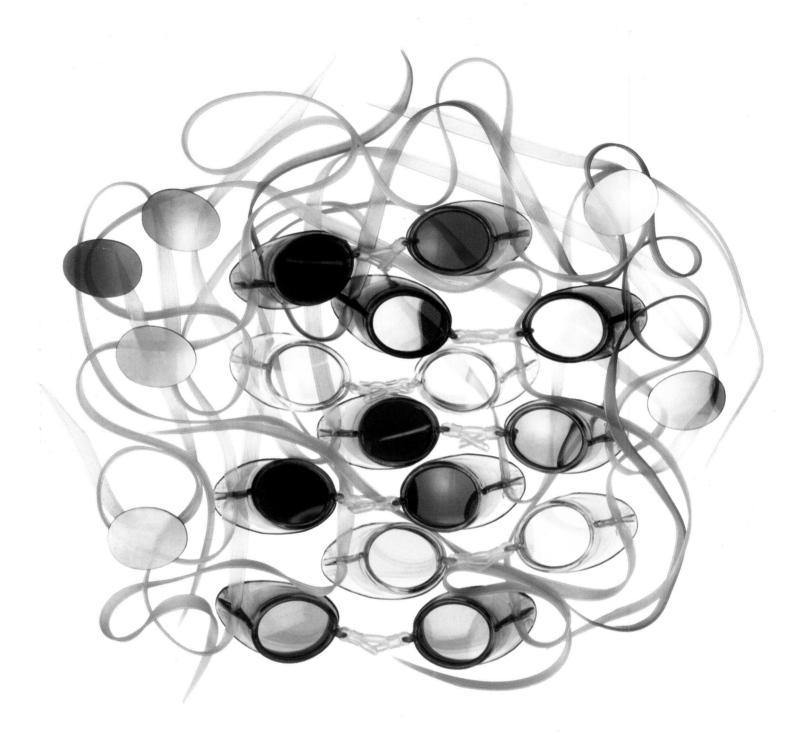

goggles

With translucent subjects the most effective solution is to light the background as well.

'These goggles come from Italy,' O'Keefe says, 'so I was interested in depicting them as a kind of visual pasta – they also look a bit as if they're floating. Because the goggles come in different kinds of glass, in that some are mirrored, some coloured and some polarised, I decided to combine back and frontal lighting.'

'The goggles were laid out on a sheet of glass, with white paper behind that, so the background and the foreground could be lit separately. This technique allows the balance to be controlled and it also prevents shadows. The white background was lit by two slim flash 'strips', which made it easy to prevent light spilling onto the subject and also meant the set could be low on the ground. The front of the goggles were lit by just one big softbox overhead.'

- Peter O'Keefe
- Robin Brew Sports
- Catalogue
- 5 x 4 inch (with 6 x 7cm roll film back)
- 210mm
- Fujichrome Provia 100
- 1/125sec at f/22
- Electronic flash

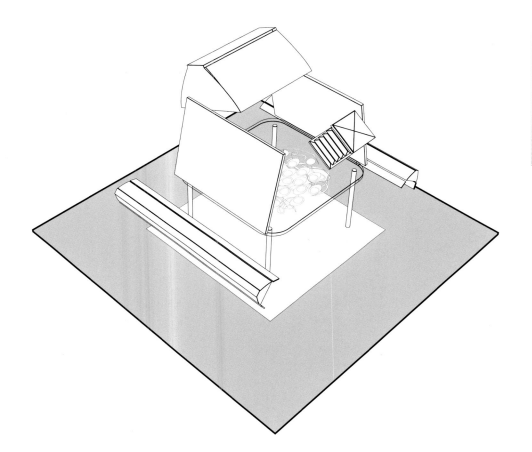

plan view

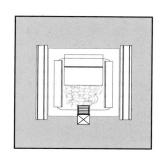

133

'This plane was part of a whole series of pictures we did for a client's brochure,' Dawes explains. 'In each case the approach was the same, beginning by spray-painting the subjects white, we even did this for an industrial digger.'

'The next stage was deciding which colours would work best together, and for that I used a colour wheel to consider the various options. Then, using coloured gels over the modelling lights of flash-heads and small spotlights, I built up the lighting until it looked right. Because these are continuous light tungsten sources, I fitted a blue correction filter over the lens. I determined the strength of this using a colour temperature meter.'

'The plane was clamped over a glass table with a sheet of Kodatrace on top and a light underneath giving the magenta background; then lights with yellow, green and red gels were positioned around the subject. The limited depth of field was created by selecting the maximum aperture of f/5.6.'

- Peter Dawes
- Waites Group
- Brochure
- 35mm
- 75mm
- Fujichrome Provia 100
- 1/30sec at f/5.6
- Tungsten

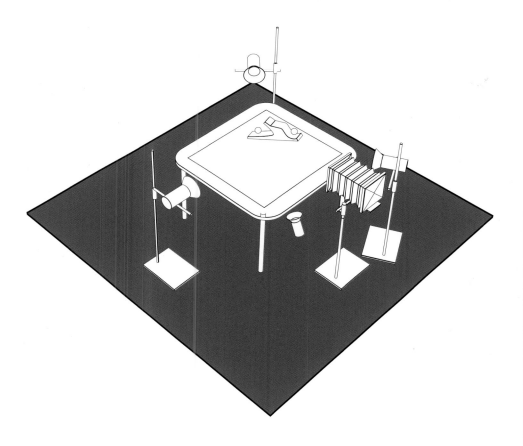

plan view

coloured plane

Creative use of lighting gels can produce almost abstract images with high impact.

This saw blade was another of the photographs in the same series as the plane. The technique was exactly the same: the blade was painted white and then illuminated with gelled lights: one purple, one red, and one yellow.

advanced lighting

painting with light

How to achieve ultimate lighting control.

While overall lighting with umbrellas or softboxes is fine for most subjects, and snoots and barn-doors can be used to narrow the output, for ultimate lighting control there's nothing to beat a dedicated lightbrush system.

With small table-top set-ups using tiny subjects, achieving the degree of lighting control required can be a nightmare. An edge that you want to highlight may only be a couple of centimetres away from an area which you want dark, and achieving that degree of precision using traditional systems can be impossible.

In such situations a purpose-made light-painting system is infinitely preferable because it allows you to place the light exactly where you want it.

Steve Allen
Royalty-free CD
5 x 4 inch
210mm
Kodak E100VS
Timed at f/8
Lightbrush

ampules

When shooting stock images it's important to make them as generic as possible – so that they can be used in as many different ways as possible. Here the ampules gives a medical feel without being too specific.

'My trademark is vivid colours,' says Allen, 'and here I used the 6mm probe on my Hosemaster lightbrush with coloured filters to separate out the different elements; with blue on the background, orange in the foreground, and plain white light in the middle.'

'I often use diagonals to make the picture look more dynamic,' he adds.

The power for a light-painting system comes from a pack with a Xenon source which can be wheeled around to wherever you want it. The difference is that instead of being connected via cables to flash heads which fire when triggered, there's a long fibre-optic hose down which the flash is channelled. At the end you have what is essentially a torch, that can be switched on and off at will. This is effectively, therefore, a flash tube that can run continuously.

Generally when light-painting you work in the dark, with the camera set to 'B'. Switching the unit on simultaneously opens a secondary shutter that's fitted to the lens of the camera and emits light from the torch. By switching the unit on and off, and moving the head around, you literally paint the subject with light. The longer you hold it on one area, the lighter it will be in the finished image. With most lightbrushes a beeping noise counts off the seconds.

With this kind of work it's impossible to use an exposure meter. However, start with a series of tests and you quickly build up the experience to know what timings and apertures to use.

The light from the raw head is incredibly bright, but a range of tools is available which allows the beam to be controlled and shaped. There is also a button which switches on a soft filter, allowing you to produce 'glow' effect selectively on parts of the image. In addition, filters are available to colour all or part of the subject.

As you might imagine, it takes some time to develop light-painting skills – but the effort is certainly worth it. Steve Allen is an expert with his Hosemaster system, and as the images on these pages show, he uses it to produce powerful photographs which would not be possible with conventional lighting techniques.

(人)	Steve Allen
(◉)	Royalty-free CD
(▦)	5 x 4 inch
(◍)	210mm
(▣)	Kodak E100VS
(◷)	Timed
(💡)	Lightbrush

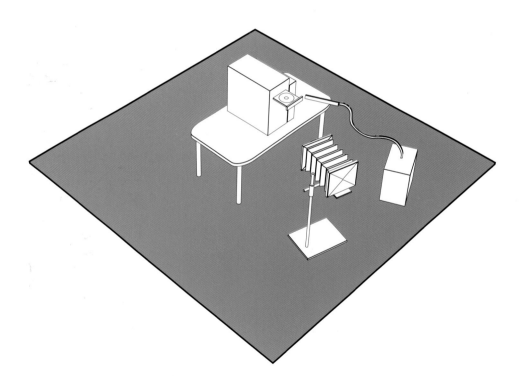

plan view

cd-rom

When using light-painting it's much easier to get the colour fringing and specular reflections that are important elements in photographing CDs. Fitting different filters also gives a dull subject a boost, though white light was used on the most important part of this subject to ensure it was the focus of attention. The finishing touch was the feeling of movement, the 5 x 4 inch transparency was scanned into the computer, and the radial blur spin filter used.

shells and starfish

This shot really would be impossible to light any other way than with the lightbrush. Creating the pools of white light required the fitting of a probe that would narrow the beam as much as possible, and the beam was then angled to bring out the velvet texture of the background. Where the background was lit, a blue filter was used to intensify the colour that was already there.

The dramatic perspective was created with a wide-angle lens used just 3 inches away from the nearest part of the subject, in order to make the image as exciting as possible.

- (⚇) Steve Allen
- (◉) Royalty-free CD
- (▦) 5 x 4 inch
- (◉) 65mm
- (▣) Kodak E100SW
- (◷) Timed at f/8
- (◌) Lightbrush

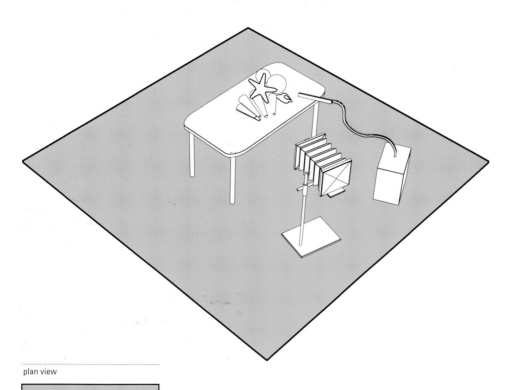

plan view

apples

Light-painting allows you to do the same kinds of things you'd do with traditional lighting, only with more precision. Here cross-lighting has been employed to reveal the texture of the water droplets, which had been mixed with a little glycerine so they stayed in place. The red came from a filter fitted over the probe.

- (⚇) Steve Allen
- (◉) Royalty-free CD
- (▦) 5 x 4 inch
- (◉) 210mm
- (▣) Kodak E100SW
- (◷) Timed at f/8
- (◌) Lightbrush

kiwano

The picture was one of a series taken of fruit in an attempt to make an oft-photographed subject more interesting through composition and lighting. The background was actually a white paper roll – the colour was created by fitting a filter over the lightbrush. White light was used for the subject itself, and the slight warmth was obtained by the choice of film stock.

 Steve Allen

 Stock

 5 x 4 inch

210mm

Kodak E100SW

Timed at f/8

Lightbrush

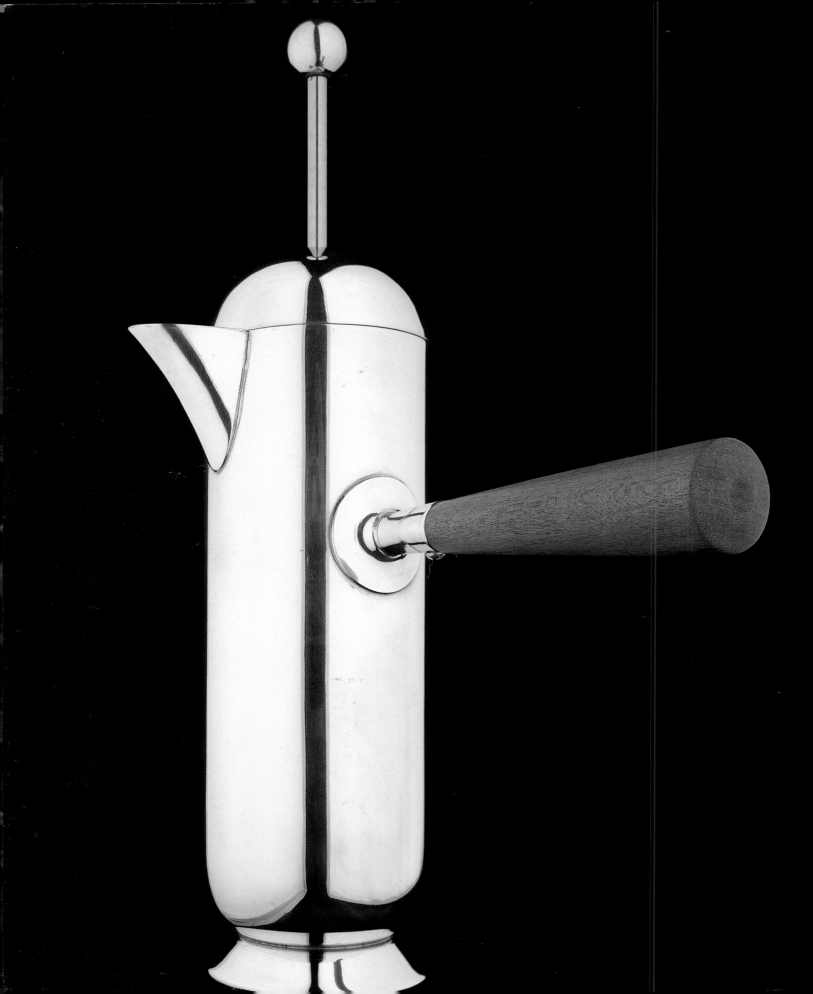

photographing shiny subjects

Lighting highly reflective subjects is a particular challenge that requires close attention to detail.

Xavier Young's photographs are exemplary examples of how to photograph shiny objects. Here he describes exactly how to manage it:

'Pewter, steel, chrome, silver... what all these subjects have in common is that they can be a nightmare to photograph. Because they're highly reflective, you can see the whole studio in them if you're not careful, and the problem is particularly bad with curved objects. Not only do you have to hide the studio, but you also have to decide what you're going to show in that reflection instead. The classic approach was to have a window-shaped reflection. The modern way is just to show a white rectangle, although it can't be just be flat white, because then you don't get any sense of three-dimensionality. You'll need to invent something to reflect in it. You also need to have some fall-off of light across the object, so you get some sense of the curvature. Really you have to figure it out for each thing individually.'

'Often with silverware you end up with a small, tight tent over the object. It all looks spaced out, but in fact you're struggling to get the lens in. You can buy light tents, but I tend to tailor the shape of the tent to the object I'm photographing by using sheets of formica.'

'Keeping polished objects clean is also important. I have white cotton gloves which allow you to make small adjustments without leaving fingerprints. Dust on reflective products isn't too much of a problem, as often it's white anyway, but you do have to watch out for it on black velvet. The secret lies in having the pile going in the right direction, so that it looks smooth rather than shiny. I both love and hate shooting reflective subjects like this, because it's always such a challenge. The important thing is not to get too clever.'

coffee pot

The reflections in this coffee pot give a good idea of how this shot was lit. There are two diffused light sources, one on each side butted up close together with the lens poking through the middle at the subject. There are also one or two lighting niceties of which you would not necessarily be immediately aware. The light on the right is actually a large softbox which has been masked down with black card to proportions that match the real striplight on the left. Also, the coffee pot is raised up on a platform below the black velvet that it's sitting on, this not only gives the effect of it floating in space but also allows the lighting to wrap around the base. If the coffee pot was sitting directly on the still-life table, a black line would occur, obscuring the curvature along the base.

 Xavier Young
 Nick Munro
Brochure
 5 x 4 inch
 90mm
Kodak Ektachrome EPR
1/60sec at f/32
Electronic flash

bowls full of chillies

'These items are even more tricky than your average silverware, because they are silvered glass – effectively a mirror,' says Young. 'It's the same technique used for making car headlamp shells and thermos flasks, and they're unbelievably reflective. The idea for these bowls is that when you put something into it the bowl appears full – here there are only a handful of chillies, but it looks a lot more. For this shot I wanted to show not only the shape of the bowl, but also that there were different sizes. My plan was to shoot straight into one and show another three-quarters behind. For that reason I used a wide-angle lens on a 5 x 4 camera, employing the movements to control the perspective.'

'The starting point was to place the bowls on black velvet, to kill all reflections from underneath. The main light is coming in from a 1 x 0.8m softbox on the right-hand side. This is resting on the table and angled at around 30 degrees. On the left-hand side is a large sheet of white Formica which meets the top of the softbox. There's then another sheet of Formica closing the gap at the front, immediately below the camera. The point where the softbox and the two sheets of Formica join up to form a triangle – and where the lens was able to see the subject – was pushed down as low as possible. To complete what is effectively a light tent, I had to close up the back with another sheet of white Formica.'

- Xavier Young
- Harvey Nichols
- Brochure
- 5 x 4 inch
- 90mm
- Kodak Ektachrome EPR
- 1/60sec at f/32
- Electronic flash

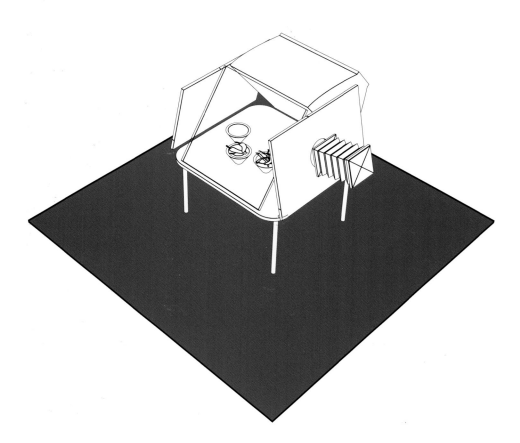

plan view

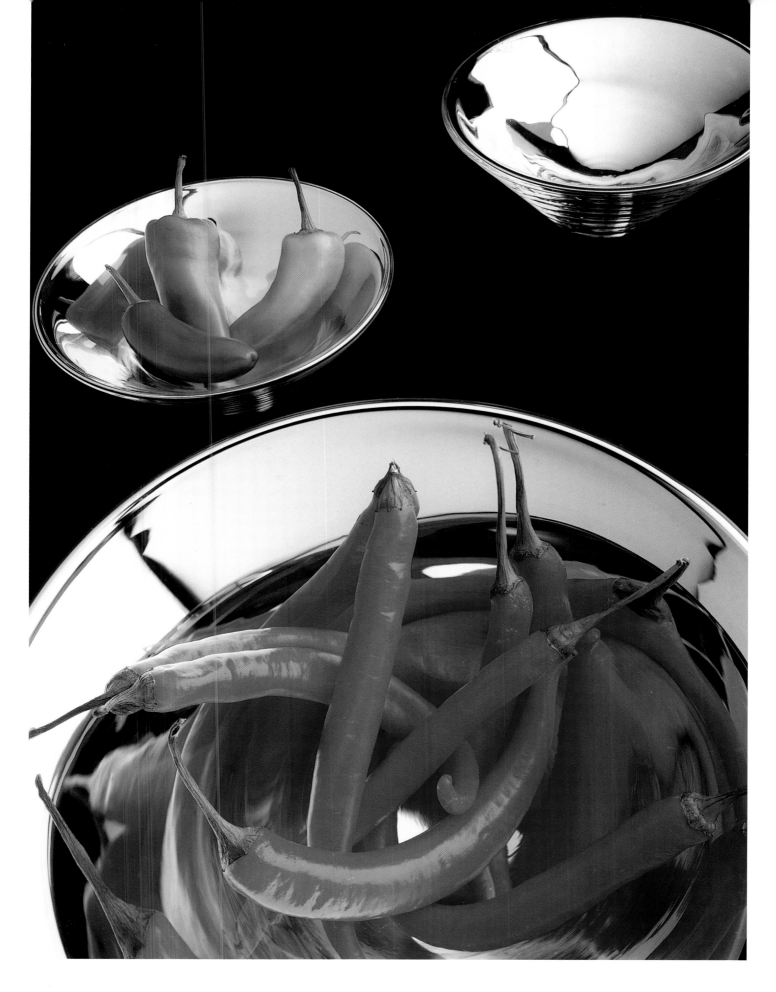

148 ## coffee mills

'I wanted to exaggerate the curve of these pepper mills, so the image needed lots of black to balance the white light. There's a striplight on the right-hand side, at right angles to the shot and angled down, so you get that dark area on the front of the pepper mills. Then, on the left-hand side, there's a sheet of Formica that's cut to the same size and shape as the striplight, and curves from the floor right over the top, forming a kind of bridge. The difficult bit was making everything black – a particular problem as I work in a white studio to preserve my sanity. I have a lot of big boards of polystyrene that are black on one side, and I built a big, black wall at the back of the set. Finally, I have a piece of velvet with a hole cut out for the lens that I draped like a curtain over the front of the lightbox and white Formica.'

Xavier Young
Nick Munro
Brochure
5 x 4 inch
90mm
Kodak Ektachrome EPR
1/60sec at f/11
Electronic flash

coffee cups

Young aimed to make these coffee cups look very architectural – but with a light and airy feel. For that reason, perspex was used as a background rather than black velvet. A makeshift still-life table with an infinity curve was fashioned out of a large sheet of perspex that was clamped into position to trestles and poles. Then there are two 'walls' of Formica, going out from the lens to almost touch the perspex scoop – with the lens poking through the slit in the middle. The only direct lighting comes from a softbox overhead, which acts like the sky. All of the other lighting was indirect, to avoid any risk of hotspots. Behind and below the perspex are large boxes made of polystyrene, into which a direct head was fired to produce even illumination.

- Xavier Young
- Nick Munro
- Brochure
- 5 x 4 inch
- 90mm
- Kodak Ektachrome EPR
- 1/60sec at f/11
- Electronic flash

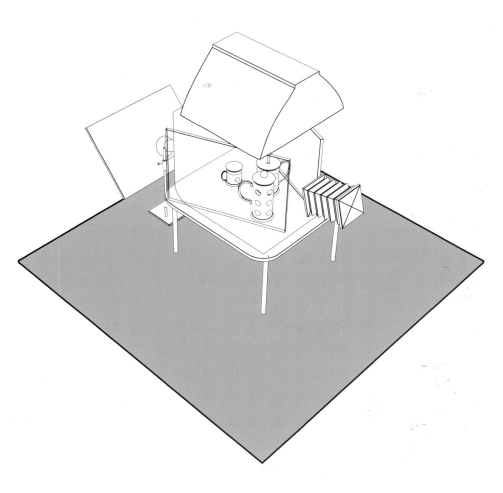

practical tips

* Formica boards make excellent reflectors because while they are strong and stable they can also be curved to meet the needs of a particular lighting situation
* Large softboxes can be modified quickly and easily with tape and black card to create a range of different lighting effects – from long, thin 'striplights' to smaller, harder light sources. You can also stick tape down in a cross shape to produce a simple window effect

plan view

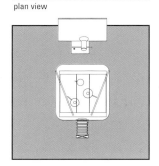

'A softbox fitted with a blue gel is lighting the side of the scissors,' describes Tilson, 'while projected onto the background is another light with the same blue gel – allowing the subject and background to be merged or separated, depending upon the exposure or the depth of field.'

'I used two snoots to create various highlights. I like snoots because the output power is cut by around a quarter, allowing you to use them closer, and the light can be controlled more accurately. I had most of the modelling lights off, but left the one illuminating the ribbon on and I used a long exposure to get the slightly blurred effect.'

Connor Tilson
Lisburn Borough Council
Promotional
5 x 4 inch
240mm lens
Fujichrome Provia 100
5 seconds at f/5.6
Studio lighting

plan view

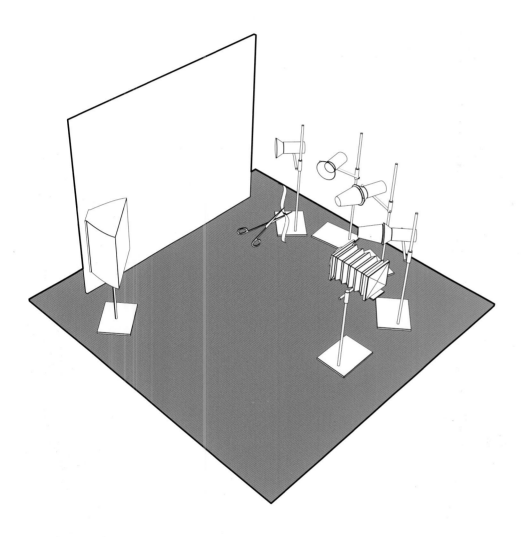

scissors

Complex lighting and a long exposure create a stunning composition.

directory

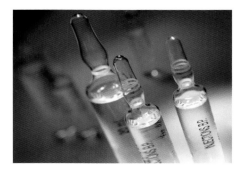

photographer	Steve Allen
address	Lindon House, The Green, Slingsby
	York YO62 4AA, England
telephone	+44 (0)1653 628687
fax	+44 (0)1653 628687
email	steve@steveallenphoto.com
website	www.steveallenphoto.com

Steve Allen is an industrial, commercial and stock photographer with 24 years experience as a professional. Stock now accounts for 65% of his turnover. He is a Fellow of the British Institute of Professional Photography and of the Master Photographers Association. Steve shoots a mixture of 5x4 and medium format, almost all on transparency film, and is an expert at Hosemaster light painting.

photographer	Tim Andrew
telephone	+44 (0)1844 237895
fax	+44 (0)1844 237895
mobile	+44 07831 391 1455
email	tim@timandrew.com
website	www.timandrew.com

Tim Andrew has worked as a professional photographer for nearly 20 years and is currently based near London. Although best known for taking superb pictures of cars, in practice he specialises in "things that go places" – such as bikes, vans and trucks. In addition, he has done a lot of portraits of industry people, but is equally at home turning his hand to interior design, landscapes and objects. He has a reputation for keeping journalists out late with elaborate flash set-ups.

photographer	Michael Bailie
address	Park House, 15 Park Street
	Thaxted, Essex CM6 2ND, England
telephone	+44 (0)1371 831158
fax	+44 (0)1371 831333
mobile	+44 07831 179801
email	mmb@baie.freeserve.co.uk

Michael graduated from Birmingham School of Photography in 1978. His career started by gaining experience in industrial and portrait photography. Following this he worked for a major publisher on a variety of magazines including Boat and Performance Car. Since 1992 he has worked as a freelance, with clients including many of the major car manufacturers. He contributes regularly to various car magazines including BBC Top Gear, WHAT CAR?, Auto Express and Thoroughbred & Classic Cars. He also undertakes other types of photography such as architectural and corporate.

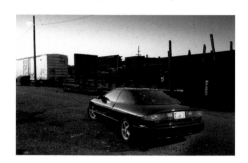

photographer	Berry Bingel
address	1 Keith Avenue, Balmedie
	Aberdeen AB23 8ZR, England
telephone	+44 (0)1358 742001/742571
email	berry@berrybingel.com
website	www.berrybingel.com

Berry Bingel was born in 1954 in Germany, got his first camera at age of 14, and hasn't stopped since. He currently lives in Scotland. His forte is corporate photography and travel – but with an increasing interest in art-orientated abstract/surrealistic effects. Berry's work has been published in corporate reports and magazines in 26 countries around the world. Whatever the job, he always looks for an unusual angle on the subject to give the client options. Formats used are 35mm and 645.

photographer	Morten Bjarnhof
address	Frederiksborgade 1A, 1360 Copenhagen DK
	Denmark
telephone	+45 33 33 01 08
fax	+45 33 33 04 08
agent	VHM Hauen Moore agent tel +44 (0)20 7629 9858
agent email	agent@vhmphoto.demon.co.uk

Morten Bjarnhof started out as an advertising photographer, moved into portraiture and made a switch into fashion in 1987 – a field in which he has been working ever since. One notable exception is his stunning product photography for Bang & Olufsen. Based in Copenhagen, Denmark, Morten does all his own black & white and colour printing. He has agents in New York, London and Denmark, and spends around half the year travelling.

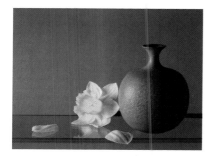

photographer	Bernard Bleach
address	Bernard Bleach Photography, Barrington House, Barrington Road
	Horsham, West Sussex RH13 5SN, England
telephone	+44 (0)1403 270888
fax	+44 (0)1403 270924
email	bernardbleachphotography@hotmail.com
website	www.bernardbleachphotography.co.uk

The work of Bernard Bleach ranges from still life to location work, encompassing food, packaging and some fashion for graphic designers and advertising agencies. Over the years clients have included Nestlé, Findus Foods, Moulinex, Sun Alliance, Dorling Kindersley, KPMG, and Ciba Geigy.

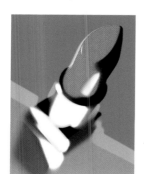

photographer	Ian Cartwright
address	Avalon Photography Ltd., 5 Pittbrook St
	Manchester M12 6LR, England
telephone	+44 (0)161 274 3313
fax	+44 (0)161 272 7277
email	ian@avalonphoto.co.uk
website	www.avalonphoto.co.uk

Ian Cartwright BA FBIPP AoP QEP is Brian Spranklen's partner at Avalon Photography. He shoots still life and people, mainly for advertising clients. A winner of many awards for his work, he is currently Chairman of the commercial photography sector of the British Institute of Professional Photography's Admissions and Qualifications Committee. He has an undying passion for image-making, whether commissioned or not.

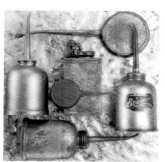

photographer	Anita Clark
address	56 Sycamore Rise, Shaw, Newbury
	Berks RG14 2LZ, England
telephone	+44 (0)1635 34966
email	anita@wenhamclarke.com

As well as having assisted many leading photographers, including Frank Herholdt, Uli Webber, Dave Stewart, Sanders Nicolson and Tim Soar, Anita Clark has shown herself to be a capable image maker in her own right. She was winner of the Fujifilm Student Awards in 1997, and has received a commendation in the KJP/Ilford Student Awards in 1998. She has also won Gold and Silver Awards from the British Institute of Professional Photography.

photographer	Peter Dawes
address	Sunningdale House, Main Road, Otterbourne
	Winchester SO21 2EE, England
telephone	+44 (0)1962 714714
fax	+44 (0)1962 714719
email	peter@pdpix.co.uk
website	www.pdpix.co.uk

Peter Dawes is a UK-based photographer with over 20 years experience in commercial and advertising photography. He has embraced the 'new technologies' as a useful creative tool but in no way is a slave to them. He is happy working both in his 700 sq ft studio and on location. He is an Associate of the British Institute of Professional Photography, and brings originality and creativity to all photography.

photographer	Colin Glanville
address	Studio 8, 26 Fromondes Road, Cheam
	Surrey SM3 8QR, England
telephone	+44 (0)20 8641 8187
fax	+44 (0)20 8641 8187
email	colinglanville@studio8.co.uk
website	www.studio8.co.uk

Commercial still life and advertising work is a major force in the life of Colin Glanville at Studio 8, but personal work is not neglected because Colin feels the freedom from commercial considerations allows scope for experimentation with techniques and ideas. A background in science (Colin has a chemistry degree) brings a studied and careful approach to problem solving allowing his artistic flair to be released. He always brings imagination and style to his photography for any subject and any client, no matter how mundane the task. Every day at work is an enjoyable day – if not Colin would do something else. He works directly for companies and through advertising agencies and graphic designers, and is currently looking for an agent to represent him.

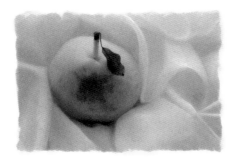

photographer	Kathleen Harcom ARPS
address	Forest View, Furzey Lodge, Beaulieu
	Hants SO42 7WB, England
telephone	+44 (0)1590 612304

A black & white photography specialist , Kathleen Harcom concentrates mainly on landscapes and still life. She aims to produce delicate, ethereal images with a timeless quality by using infrared film combined with lith printing and toning. Kathleen likes to print her work personally because it gives her precise control over the final image. She is an Arena member and Associate of the Royal Photographic Society. As well as writing articles for Practical Photography magazine, she has had pictures published in Creative Monochrome books and several magazines.

photographer	Paul Harwood
address	Cleveland Place, Friar's Road, Winchelsea
	East Sussex TN36 4ED, England
telephone	+44 (0)1797 225358
email	harwood@dial.pipex.com

Paul has worked in design and photography for over 20 years, mainly in the magazine and book publishing worlds. He likes to plan photography with a strong graphic element as befits his background. He will photograph anything, but has recently specialised in unusual lighting set-ups for illustrative use.

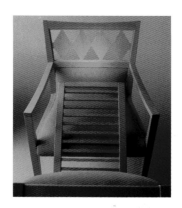

photographer	Mike Hemsley
address	Walter Gardiner Photography, Southdownview Road, Worthing
	West Sussex BN14 8NL, England
telephone	+44 (0)1903 200528
fax	+44 (0)1903 820830
email	wgphoto@compuserve.com
website	www.wgphoto.co.uk

Mike Hemsley is a specialist in industrial, commercial advertising photography whose work demonstrates enormous creative flair. A Fellow of the British Institute of Professional Photography, he studied at Salisbury College of Art and Design. His studio is now 107 years old. 'Throw me into a room and I'll come up with an interesting image,' he says. 'I don't need countless meetings with Art Directors to produce good photographs – though I'm equally happy working to a brief.' He works with all formats up to 10 x 8 plus digital.

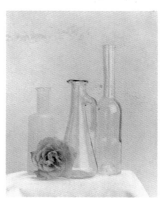

photographer	Caroline Hyman
address	Caroline Hyman Photography, Stud Farm House, Skirmett
	Henley-on-Thames, Oxon RG9 6TD, England
telephone	+44 (0)1491 638321
fax	+44 (0)1491 638829
email	caroline.hyman@btinternet.com
website	www.carolinehymanphotos.co.uk

Caroline Hyman began her career as assistant to a top fashion photographer. She specialises in black & white-toned and hand-coloured limited edition photographs and prints her own work. Caroline's subjects are mainly found close to home in the countryside surrounding her farmhouse, but she also makes good use of trips abroad. She has won numerous photography awards and was recently described by leading British photographer Terry O'Neil as, 'The Georgia O'Keefe of the camera'. She is a Fellow of the Royal Photographic Society, a member of Arena, and is represented by Focus Gallery in London.

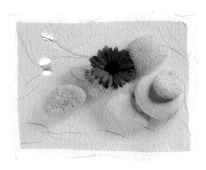

photographer	Ivor Innes
address	Ivor Innes Ltd., Pryme Street, Anlaby
	East Yorkshire HU10 6SH, England
telephone	+44 (0)1482 653667
fax	+44 (0)1482 653673
email	ivor@ivor-innes.co.uk
website	www.ivor-innes.co.uk

Ivor is a leading advertising photographer, with blue-chip clients including Conran Design, Wolf Olins, Bray Brothers, Mark & Spencer, Northern Foods, Sun Valley and Asda. His specialisation is food and room sets, in formats from 35mm up to 10 x 8 plus digital – and has on-site E-6 processing facilities. Ivor has been a professional photographer all his working life and is, he says, 'in the business of selling products for people'.

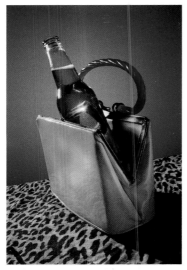

photographer	Chas Ray Krider
address	219 King Avenue, Columbus
	Ohio 43201, USA
telephone	+1 (614) 299 9709
fax	+1 (614) 299 9797
email	chasray@ee.net
website	www.motelfetish.com

Chas uses a minimalist approach in his work, with as few design elements as possible – just object, surface and background. He attempts to evoke what he calls the 'psychological significance' from the object. He achieves this through object distance, which in turn is determined by object scale and his lens choice. 'I know when everything is correct by how the image "feels" as well as how it looks. Through a tight formal composition, lighting and camera placement, I am attempting to set up a certain "tension" for maximum psychological impact. In my personal work, versus commercial work, where I can select my own objects, I will set up an unsettling juxtaposition. This is a relationship in which the object encounters the unexpected, whether it be the surface on which it finds itself (red meat on green shag pile) or in what the object is placed (bottle in purse). Colour and lighting choices serve to heighten the visual intensity. I like to set up an image where I seduce the viewer, through rich colour and a beautiful composition, into the image before they can read the visual idea. There is an attraction and a repulsion at the same moment. This method of working is a simple and classical surrealist technique.'

| photographer | Simon McCann |
| mobile | +44 (0)7944 888581 |

Simon McCann shoots mainly editorial for magazines such as The Face and Arena and newspapers such as The Sunday Times and the Independent – although he has also worked directly for clients such as Adidas and Kronenberg. Recently he has been exploring creating more abstract images of the things he's photographing, and has been experimenting with ultraviolet lighting.

photographer	Graeme Montgomery
address	4 Roberts Place, off Bowling Green Lane
	London EC1R 0BB, England
telephone	+44 (0)20 7253 0853
fax	+44 (0)20 7253 0852
email	graeme@gmonty.demon.co.uk

Graeme Montgomery is a leading international fashion still-life photographer, who has worked for magazines such as Harpers & Queen and L'Uomo Vogue, and advertising clients including Mulberry, Dunhill and Asprey. Whether the product is a bottle of perfume or a silk tie, his lean, simple lighting and consummate sense of good composition can be relied upon to make the most of it.

photographer	Peter O'Keefe
address	Titchfield Studios Ltd., 23 Mitchell Close, Segensworth East
	Fareham, Hampshire PO15 5SE, England
telephone	+44 (0)1489 582925
fax	+44 (0)1489 885107
email	titchfieldstudios@btinternet.com

Peter O'Keefe is a highly skilled commercial, industrial and advertising photographer. He is a Fellow of the British Institute of Professional Photography, and a member of the Association of Photographers. Peter originally trained at art college as a technical illustrator, and eventually turned to photography after a short spell in graphic design. Consequently a strong graphic quality is evident in much of his photography. Working mainly in his studio near Southampton, his sense of design is complemented with many special effects techniques employing both conventional and now digital methods. Paying close attention to detail while pushing at the boundaries of creativity has led him to win many clients and awards. He is now working for agencies and client companies in the South of England, primarily for electronics-based businesses and drinks marketing companies.

157

photographer	Louisa Parry
address	Unit 3 Basement, Perseverance Works, 38 Kingsland Road
	London E2 8DD, England
telephone	+44 (0)20 7729 5899
fax	+44 (0)20 7729 5939
email	parry.louisa@virgin.net

Having completed a degree in photography, Louisa set up her own studio in Shoreditch in 1998. As well as being technically brilliant, she believes it's important to have a strong idea behind the image – and loves being allowed to have as much input into the picture as possible. Clients to date have included Gieves & Hawkes, Ted Baker, Gordon's Gin, Halfords and Vodaphone along with magazine commissions from Arena, Vogue and GQ.

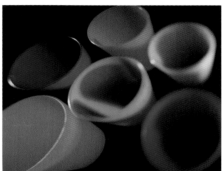

photographer	Alan Stone
address	Stones Imaging, The Hayloft Studio, Home Farm, Wakefield Road
	Swillington, Leeds LS26 8UA, England
telephone	+44 (0)113 287 6700
fax	+44 (0)113 287 6700
mobile	+44 07712 629228
email	alan@stonesimaging.co.uk
website	www.stonesimaging.co.uk

Alan has worked in professional photography since leaving the Royal Navy in 1975. He has always specialised in advertising and corporate photography and has also had a successful 12 year lecturing career in photography education at Higher National level. He now runs his business, Leeds-based Stones Imaging, with his wife Keeley. The business specialises in advertising, corporate and fashion photography and computer-based imaging. Studio-based advertising work is where Alan excels and he is currently considering expanding into digital photography if demand continues.

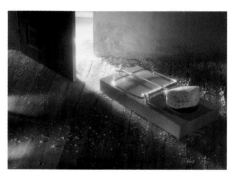

photographer	Connor Tilson
address	Digipix Foto, 68 Upper Malone Road
	Belfast, BT9 5PD
telephone	+44 (0)2890 300075
mobile	+44 07779 725066
email	connortilson@digipixfoto.co.uk

As a photographer for Manleys, a leading 'one-stop-shop' for PR, design and print, Connor Tilson produced advertising, industrial and commercial images for a wide range of clients including BT, Northern Irish Electricity and Tesco. An Associate of the British Institute of Professional Photography, he uses mainly medium and large format equipment, and is an expert in lighting and composition. 'I never, ever, stop experimenting,' he says.

photographer	Neil Warren
address	Turnford
	Hertfordshire, England
telephone	+44 (0)1992 427372

Neil Warren studied photography at the Kent Institute of Art and Design and was accepted as an Associate of the British Institute of Professional Photography at the age of just 22. Since then he has proved his abilities in most areas of photography, starting out shooting weddings and more recently working as a commercial and industrial photographer. He particularly enjoys food photography, but is equally at home with executive portraits and fashion. Neil especially likes producing graphic compositions using design and layout elements.

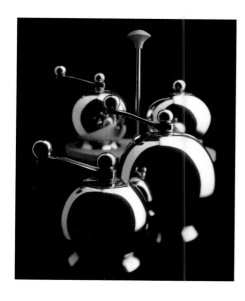

photographer Xavier Young
address 5 Torrens St, Angel
 London EC1V 1NQ, England
telephone +44 (0)20 7713 5502/+44 (0)1273 735078
mobile +44 07966 296731
email xavier.young@virgin.net

Xavier Young started taking still-life photographs as a diversion from his predominately black & white portrait work for the music and editorial sectors. In early 1996 however the Telegraph magazine commissioned him to shoot their 'Shopfront' section, and since then the still-life work for magazines, colour supplements, book publishers and design consultancies has dominated his output. His work has been reproduced in several design and photography annuals and he has won awards for his work on books and corporate brochures with Struktur Design. Xavier works both from his central London studio and from his home in Brighton.

would you like to see your images in future books?

If you would like your work to be considered for inclusion in future books, please write to: The Editor, Lighting For..., Rotovision SA, Sheridan House, 112–116A Western Road, Hove, East Sussex BN3 1DD, UK. Please do not send images either with the initial inquiry or with any subsequent correspondence, unless requested. Unsolicited pictures may not always be returned. When a book is planned which corresponds with your particular area(s) of expertise we will contact you.

acknowledgements

Thanks must go, first and foremost, to all of the photographers whose work is featured in this book, and for their generosity of spirit in being willing to share their knowledge with other photographers.

Thanks also to those companies who were kind enough to make available photographs of their products to illustrate some of the technical sections.

Finally, enormous thanks must go to the talented team at RotoVision, including Editor Kate Noël-Paton; to Ed Templeton and Hamish Makgill from Red Design for the stylish layout; and to Sam Proud from Mosaic for his clear and elegant illustrations.

159